# The nature of design

Cover: Regulator clock by Benjamin Vulliamy, *c* 1780,
with outer back plate removed
*Crown Copyright, Science Museum, London*

Frontispiece: Church of St John the Baptist,
Campi Bisenzio, near Florence. Designed by
Professor Giovanni Michelucci *I.R.I., Rome*

# The nature of design

David Pye

Studio Vista: London

Reinhold Book Corporation: New York

A Studio Paperback edited by John Lewis

A STUDIO VISTA/REINHOLD ART PAPERBACK
EDITED BY JOHN LEWIS
© DAVID WILLIAM PYE, 1964
REPRINTED 1967, 1969
PUBLISHED IN LONDON BY STUDIO VISTA LTD.
BLUE STAR HOUSE, HIGHGATE HILL, N 19
AND IN NEW YORK BY REINHOLD BOOK CORPORATION
430 PARK AVENUE, NEW YORK, NY 10022
LIBRARY OF CONGRESS CATALOG CARD NUMBER 64-23104
SET IN 10/13 GARAMOND
PRINTED IN THE NETHERLANDS
BY DRUKKERIJ RECLAME N.V., ROTTERDAM
SBN: 289 36845 6

# Contents

Acknowledgements

The Japanese woodcuts used as illustrations are from
Hokusai's 'Hundred views of Fuji'.
I am particularly indebted to Mr Basil Taylor,
Miss Patience Aspinall, and Mr Colin Hayes for
criticism and advice: to Miss Joan Beach, who typed
the manuscript: to those who gave photographs;
which are individually acknowledged: and to Mr John
Lewis, the editor of this series, for help of many kinds
and for the trouble he has taken over designing this
book on design.

Die-sinking: Head of Arethusa.
Tetradrachm of Syracuse,
5th century BC

*By permission of the Trustees,
the British Museum*

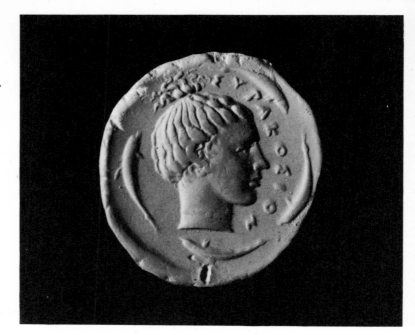

Calligraphy: from
*The Old Drunkard's Arbour.*
Ascribed to Sung Dynasty

*By permission of the Trustees,
the British Museum*

This book is not about aesthetics but about design and making, two of the principal human activities, and ones informed both by art and by science. If anyone thinks it important to civilisation that a common ground between art and science shall be found, then he had better look for it in front of his nose; for it is ten to one that he will see there something which has been designed.

The art of design, which chooses that the things we use shall look as they do, has a very much wider and more sustained impact than any other art. Everyone is exposed to it all day long. Indeed, in towns there is hardly anything in sight except what has been designed. The man-made world, our environment, is a work of art, all of it, every bit of it. But not all good.

As someone very properly said 'Art ain't all paint'. Diesinking and calligraphy have each been rated of equal importance with painting in their day and place. Whether anyone now thinks design more or less important than painting, is not a matter of importance. But it is important that design shall be good, if only because, unlike the fine arts, it is inescapable.

Although the importance of design is realised, the essential nature of the activity seems not to be understood except by designers, and they have not formulated what they know. It is not of the slightest use for us to ask 'what is good design?' until we can answer the question 'what *is* design?'

The thing which sharply distinguishes useful design from such arts as painting and sculpture is that the practitioner of design has limits set upon his freedom of choice. A painter can choose any imaginable shape. A designer cannot. If the designer is designing a bread knife it must have a cutting edge and a handle; if he is designing a car it must have wheels and a floor. These are the sort of limitations which arise, as anyone can tell, from the 'function' of the thing being designed.

Little is ever said which touches on the fundamental principles of useful design, and what is said is often nonsense. Most of the nonsense probably starts at the point where people begin talking about function as though it were something objective: something of which it could be said that it belonged to a thing.

The dictionary defines function as 'the activity proper to a thing, the mode of action by which it fulfils its purpose'. What (on earth) can that mean? Surely if there were activities proper to things, and if things acted, and if they had purposes, Newton might have been relied on to take note of these facts? 'Function' will not square with physics. And if function is a fantasy, what of functionalism – the doctrine that form follows function?

What is the activity proper to a straight cylindrical bar of steel a quarter inch in diameter on cross section and four inches long? What function is this form following, or ought it to follow? What activity exclusively and distinctively belongs to this thing, is in other words proper to it? There it lies on the bench; what are we to say? — 'Well, it isn't active. You could make it active if you heated it enough. Otherwise it will not do anything unless the bench happens to collapse. Of course you could use it for an enormous number of different purposes, but then for nearly every one of them you could use something different equally well . . .' The question has still to be answered, 'what is the function of this thing?'

Now plenty of people do really believe that form can follow function; that if you thoroughly analyse the activity proper to the thing you are designing, then your analysis will provide all the information needed, and the design can be derived logically from the function. Plenty of people still believe that 'purely functional' designs are possible, and believe that they themselves produce them, what is more! But none of them has yet divulged what an analysis of a function looks like and what logical steps lead from it to the design. All you will get from them is talk about the purpose of the thing, which, as we shall see, is a statement of opinion and can never be anything else.

Someone will reply 'This is all pedantry. Think out what the thing has got to do, design it in the simplest form which will do that and there you have a purely functional design; and what is more it will look right.'

This sort of assertion raises three questions:

1 How do you determine what the thing you are going to design 'has got to do', what 'activity is proper to it', what 'it is for', what 'its purpose' is?

2 Having done so, does the information you have gained govern the design and determine its form, or does it merely guide it, restricting the choice of form and setting limits within which it can be varied at will?

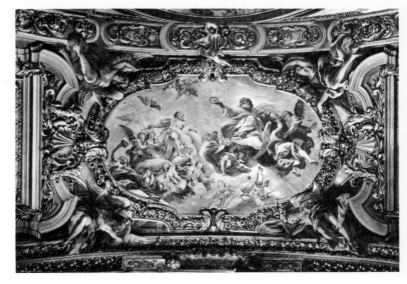

3 What does 'purely functional' mean?

We shall have to consider the implications of all three questions at some length in the chapters which follow. We shall find that the answer to the first question is, 'arbitrarily'. The answer to the second question is 'it merely guides it', *for the form of designed things is decided by choice or else by chance; but it is never actually entailed by anything whatever.* Nothing in the realm of design ever 'looks like that because it has got to be like that' as some eminent person said on television. The answer to the third question is in practice, 'cheap', or else 'streamlined', or else, more rarely, 'light'.

Anyone can verify by simple observation two important facts. The first is, that whenever humans design and make a useful thing they invariably expend a good deal of unnecessary and easily avoidable work on it which contributes nothing to its usefulness. Look, for instance, at the ceiling. It is flat. It would have been easier not to have made it flat. Its being flat does not make you any warmer or the room above you any quieter, nor yet does it make the house any cheaper; far from it. Since there is a snobbism in these things flattening a ceiling is called workmanship, or mere craftsmanship; while painting gods on it or putting knobs on it is called art or design. But all these activities: 'workmanship', 'design for appearance', 'decoration', 'ornament', 'applied art', 'embellishment', or what you will, are part of the same pattern of behaviour which all men at all times and places have

9

followed: doing useless work on useful things. If we did not behave after this pattern our life would indeed be poor, nasty and brutish.

The second fact, which can be verified by simple observation, is that all useful devices have got to do useless things which no one wants them to do. Who wants a car to get hot? Or to wear out its tyres? Or to make a noise and a smell?

The concept of function in design, and even the doctrine of functionalism, might be worth a little attention if things ever worked. It is, however, obvious that they do not. Indeed, I have sometimes wondered whether our unconscious motive for doing so much useless work is to show that if we cannot make things work properly we can at least make them presentable. Nothing we design or make ever really works. We can always say what it ought to do, but that it never does. The aircraft falls out of the sky or rams the earth full tilt and kills the people. It has to be tended like a new born babe. It drinks like a fish. Its life is measured in hours. Our dinner table ought to be variable in size and height, removable altogether, impervious to scratches, self-cleaning, and having no legs. The motor car ought to stop dead, and no one in it be thrown forward, in the same instant that you press a button. We cannot console ourselves with the belief that such things are impossible. Who would ever have believed that a child could light a whole room by moving its finger?

Never do we achieve a satisfactory performance. Things simply are not 'fit for their purpose'. At one time a flake of flint was fit for the purpose of surgery, and stainless steel is not fit for the purpose yet. Every thing we design and make is an improvisation, a lash-up, something inept and provisional. We live like castaways. But even at that we can be debonair and make the best of it. If we cannot have our way in performance we will have it in appearance.

Few people, perhaps, will accept this. An old lady was seen to look skywards as one of the earliest flying machines passed overhead and was heard to say 'Of course, my dear, they'll never *fly*'. The blatantly obvious is seldom easy to believe! But one day the dictionary may read, 'FUNCTION. What someone has provisionally decided that a device may reasonably be expected to do at present.'

When any useful thing is designed the shape of it is in no way imposed on the designer, or determined by any influence outside him, or entailed. His freedom in choosing the shape is a limited freedom, it is true, but there are no limitations so close as to relieve him or the maker of responsibility for the appearance of what they have done. The ability

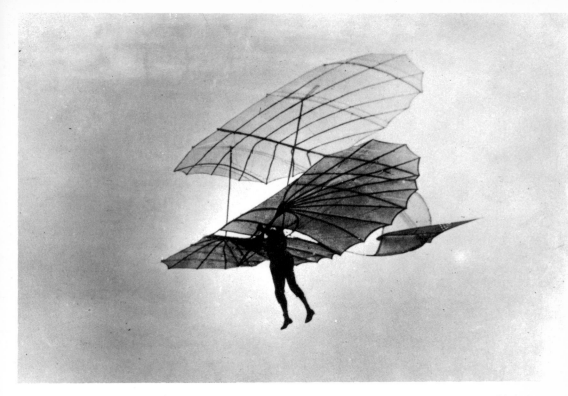

'The ability of our devices to get results depends less exactly on their shape than we are apt to think .'
Otto Lilienthal gliding, 1896

of our devices to 'work' and get results depends much less exactly on their shape than we are apt to think. The limitations arise only in small part from the physical nature of the world, but in a very large measure from considerations of economy and of style. Both are matters purely of choice. All the works of man look as they do from his choice, and not from necessity.

This book has been written in an attempt to answer the question: 'of what kinds, precisely, are the limitations on his choice and their causes?'

We are here concerned with devices; things designed for use: buildings, ships, vehicles, tools, furniture, clothes, and so forth, and not with things designed solely for contemplation such as pictures and statues.

Of all devices designed for use it may be said that they are intended to get some result which was not there before; some objective and measur-

able result, such as a man warmer or cooler than before (building, clothes), a thing transported to a new place (ship, vehicle), a thing in two pieces which was in one (tool), a man supported who was self-supported (bed).

There is a distinction between the result of a device's being used and the purpose of it. The kind of result which, for example, cargo vessels are intended to realise is cargo transported overseas. All cargo vessels are, as a matter of ascertainable fact, designed, built, paid for and handled, to achieve *that kind of state of things*. As for the purpose of those vessels, if God knows all men's minds, then we may say that God alone knows what their purpose may be; for the purpose of a ship is any purpose imputed to it by any man. To the owner the purpose of the ship may be to make money. To the captain it may be to ply the seas. To the designer it may be to carry four thousand tons of cargo at ten knots. To the enemy it may be to compass his defeat. The purposes of things are the purposes of men and change according to who entertains them. They change, moreover, when a man's mind changes. My motor car has at present, perhaps, the purpose of taking the children to school. But I think, perhaps, that the time has about come when its purpose should change to housing the chickens. Then the purpose of my car is housing chickens and that is all about it. But the states of things, i.e. results, which that same car is capable of achieving are matters of fact, not of someone's whim, not affected by anyone's purpose. The fact that every device when used produces concrete, measurable, objective results, is the only sure basis for the theory of design. Any concept such as 'function' which includes the idea of purpose is bound to be an unsafe foundation; for purpose leaves commonplace factual affairs like results far behind.

Wherever there is a result there has been a change, and all changes in the world are produced by the passage of energy. Since an understanding of the nature of results is the key to an understanding of the nature of design, we shall have to take note of certain facts about energy.

The first fact is that energy is manifested in several different forms any of which can be transformed into another. Thus by means of a furnace the chemical energy of coal is transformed into heat energy. The heat energy, by means of a steam boiler, turbine, and generator is transformed into electrical energy. The electrical energy may be transformed by a lamp into the form of energy we call light, or by an electric motor it may be transformed into kinetic energy – the energy of move-

ment – which is applied to move, say, a train; so that transport is an end result of the chain of transformations.

Any one of these forms of energy is capable of producing changes, changes in things; more exactly, redistributions of matter. The various ways in which matter can be redistributed are: shifting – that is to say, moving bodily; deforming – bending, stretching, compressing etc.; dividing – splitting, powdering, cutting, abrading, etc.; joining – welding, fusing, adhesion, etc.; change of state – melting, solidifying, vapourising. But all of them in the last analysis amount to shifting. Any redistribution of matter, any and every result other than a transformation of energy which a device can be used to get, amounts to a shifting of things or to a holding of them still, whether they be mountains, molecules or men.

Now whenever a change is made, by the passage of energy, and a result is left, this event takes place in a group of things. Things are always together. They do not exist separately and they cannot act separately. For present purposes we shall call a group of things in which a change takes place, a system. The word does not necessarily imply anything 'systematic' in the ordinary sense, or organised, such as a man, or a machine. It may do so, and often does, since any device is a system. But it need not. So far as the theory of energy is concerned, a heap of scrap iron is as good a system as an electronic computer, a house, or the state of Massachusetts.

'A System'

*Keystone*

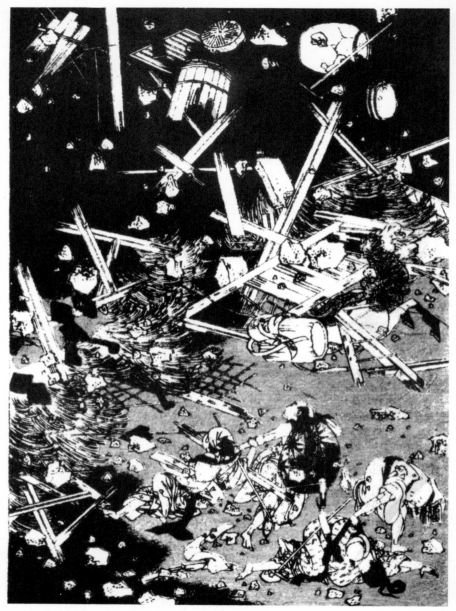

'*Panta rhei*'. Hokusai's picture of energy. An eruption

Everything everywhere may be regarded as a component of a system. It is fruitless to consider the action of a thing without considering the system of which it is a component. This fact has a special importance for designers in various fields because they tend to think of things separately and to design them separately. We ought not to do this if we can help it. We ought at least to remind ourselves that we are concerned with a whole system even if we are only able to effect the design of one component. It is arguable that the locomotive engineers of the nineteenth century had more vision than the automobile engineers of the twentieth; for in the nineteenth century they conceived of the vehicle and its road as one system and designed them together.

It is well to remember that by the time-scale of the universe the shapes of all things and systems are as fugitive and evanescent as those of clouds driven before a gale, which coalesce and dissolve as they go. Energy is the gale. *Panta rhei.*

When energy in any of its several forms is put into a system of any kind, changes take place, both in the energy, which suffers transformations, and in the components of the system, where various redistributions of matter occur. The changes in such a system as a motor car and road, for example, are familiar enough: chemical energy turns into heat energy and that into kinetic energy; gases expand, parts of the car shift, parts vibrate, bearings wear, tyres wear, sound waves are generated, stones are thrown aside, and so on. Events of just the same kind occur in a heap of scrap iron if energy is put into that by, say, compressing it in a powerful press. Kinetic energy is transformed into heat energy; pieces shift, vibrate, change their shape, expand under heat, wear away or break up. In neither of these cases, nor in any other, is energy dissipated, in the sense of being lost. Energy is indestructible. When it passes through a system it is transformed but never lost. It ends up as heat, widespread and at a low temperature, and so is no longer accessible to our use, but it has not been destroyed.

When you put energy into a system you can never choose what kind of changes shall take place and what kind of results shall remain. God has already decided those things. All you can do, and that only within limits, is to regulate the amounts of the various changes. This you do by *design*, which is the business of ensuring that at least you get the change you want along with all the others which you don't such as heat, noise, wear, and the rest. It is as though the world operated on the principle of 'truck'. If you want some of this then you must take some of that as well, even though you do not want it.

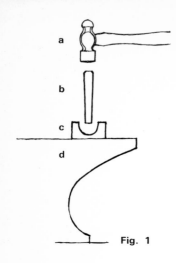

a

b

c

d

**Fig. 1**

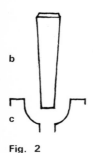

b

c

**Fig. 2**

Whenever we design something we do so in order to get an intended result. Along with that we get unwanted results. The total of all the results together we may call the 'response' of the system to the input of energy. The particular things which are involved in the intended result itself, we may call the 'objects'. In this book that word will be used to refer to a thing and not a thought.

Design – useful design, that is to say – is the business of adapting a known system so as to get at least the intended result, when energy is deliberately put in or admitted to the system. In structures, however, energy is constantly being put in by gravitation. Here the designer's purpose is not to get a particular result but to avoid getting one. He has to ensure that the response does *not* include at least one kind of change – shifting. He can, and must, put up with strain and deformation of various kinds, but shifting will not do at all.

We can never select the one result we want to the exclusion of all others, and neither can we select one source of energy to the exclusion of all others. There are all too many sources which supply energy we do not want. Design is concerned as much with averting the possible consequences of unwanted inputs of energy as it is with getting the intended results from energy which we can control. The sun persists in heating things; the wind blows things over; moth and rust corrupt; and, above all, gravitation never lets up. The architect is concerned almost entirely with uncontrollable sources of energy (except of course in the mechanical equipment of buildings); while all design of every kind is concerned in part with gravitational energy.

Let us now consider the system in Fig. 1. Someone puts energy in by way of A, a hammer which hits B which hits C which is supported by the anvil D. Suppose that B is cold steel and C is red-hot steel. The intended result is presumably as in Fig. 2: from which we deduce that B is the tool and C the object. But now suppose that B is red-hot and C is cold. The intended result is now presumably as in Fig. 3, more or less. Previously we called B 'a tool' and C 'the object' or, probably, 'the job'. Now however we call C the tool and B the job. We judge by results. Devices of all kinds are classified by their results, not by their form. You cannot tell what result the system will produce until you have found out the relative hardness of B and C. The 'modes of action' of B and C or the 'activities proper to them' – their functions – are independent of their forms. I do not know how the functionalists managed to avoid noticing this fact, but they seem to have managed wonderfully well, considering.

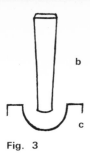

**Fig. 3**

Figs. 1–3 illustrate the fact that the designer can only ensure that the intended results do occur, by selecting certain properties for its components, namely those required by the nature of the result, of the objects, and of the energy put in. That in principle is his job.

From this it follows that shape is not really his primary concern at all. It also follows that, as everyone knows, it is possible to design things which cannot be made. I have designed an axe and a knife which are an immense improvement on anything of the kind which exists. Their edges are ground to a bevel of one degree and they keep their edge indefinitely. Unfortunately we cannot make them, yet. As for our present axes, they do not work. Axes are meant for cutting down trees, not for making a lot of piddling little chips.

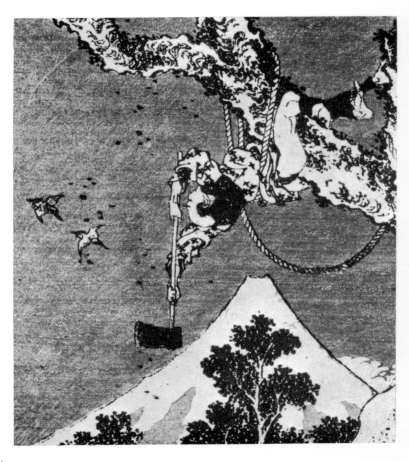

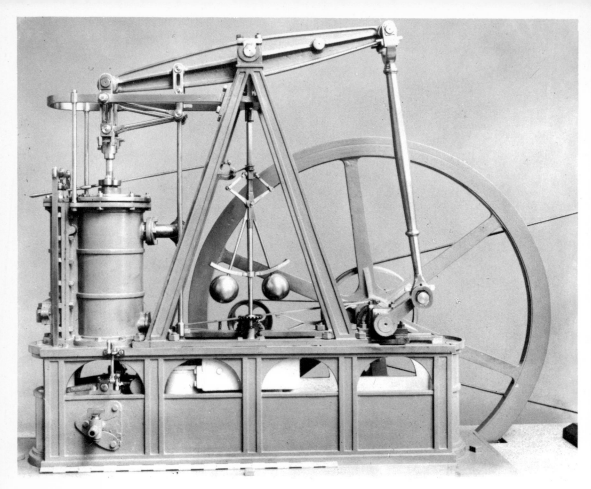

James Watt's 'cabinet' steam engine. After 1800

*Lent to the Science Museum, London, by A. Greg Esq*

Although in many fields designers quite frequently make inventions, designing and inventing are different in kind. Invention is the process of discovering a principle. Design is the process of applying that principle. The inventor discovers a class of system – a generalisation – and the designer prescribes a particular embodiment of it to suit the particular result, objects, and source of energy he is concerned with.

The facts which inventors discover are facts about the nature of the world just as much as the fact that gold amalgamates with mercury. Every useful invention is a discovery about the way things and energy can behave. The inventor does not make them behave as they do.

'A system of this kind' means, 'this way of arranging things'. There is a principle of arrangement underlying each class of device. In some cases, for instance Supports or Enclosures, it is extremely simple. In others it is not. An inventor's description of the essential principle of a more intricate device, might be worded as follows: 'If you have a wheel, and if at any place except the centre you fix to it a pin standing at right angles to the plane of the wheel, then (provided always that the system is properly designed) the wheel can be turned by the piston rod of a reciprocating engine. It must be linked to the piston rod by a connecting rod which is longer than the distance from the centre of the wheel to the crank pin. One end of the connecting rod must be hinged to the piston rod so that it is free to swing, and the other end must be pivoted on the pin so that the pin can rotate freely in it'.

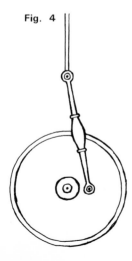

**Fig. 4**

The piston rod, connecting rod, and crank pin are 'the device'. The wheel is 'the object'.

For the sake of brevity this description of an invention for converting reciprocating motion into rotary motion has not been worded to cover all conceivable instances; and would no doubt have been worded better by a patent agent – whose job it is to write such things — but it will serve to illustrate the essential point that while the description is virtually complete and comprehensive, the accompanying Figure (4) is very incomplete although easier to understand. The description describes the essential principle of the device, which is purely a matter of its arrangement. Almost every conceivable instance is covered by the description. The Figure on the other hand merely describes one particu-

lar embodiment of the invention. Someone failing to guess the essence of the invention from the Figure might suppose that the swelling in the connecting rod was essential. Whereas the connecting rod can be of almost any shape provided it is properly designed. Shape is among the least important properties of a connecting rod, not much more important than colour. But for that matter shape is not all important even to a ball bearing. No two are the same shape and certainly none of them is spherical.

The description says nothing about the shapes of the components of the system. 'A wheel' it says. The wheel may be a Geneva wheel, of a complicated star shape. The pin could be triangular in section. The connecting rod could well be in the shape of a dragon. The hinge could be made of eel-skin like a flail's. And still the thing could work. The description says distinctly how the parts are related to each other in arrangement without saying what they are like. The relations between them which it describes are those which determine in what direction energy can and cannot be transmitted from one to another. Quite a complicated relation is often implied by one word. The word pivot, for instance, implies a pair of things one of which embraces the other but cannot, except by friction, transmit turning forces to it.

It is really rather remarkable that, while anyone can tell whether a thing is a pocket-knife because, presumably, anyone can recognise the principle of arrangement which constitutes the similarity between all pocket knives, no one can *visually* abstract that arrangement. We recognise it when we 'see' it embodied, we can describe it disembodied, but we cannot visualise it disembodied.

When a device embodying some known essential principle of arrangement such as we have discussed is to be adapted and embodied so as to achieve a particular result, there are six requirements to be satisfied:

1 It must correctly embody the essential principle of arrangement.
2 The components of the device must be geometrically related – in extent and position – to each other and to the objects, in whatever particular ways suit these particular objects and this particular result (Chapter 4).
3 The components must be strong enough to transmit and resist forces as the intended result requires.
4 Access must be provided (this is a special case of 2 above).

These four together will be referred to as *the requirements of use*.

5 The cost of the result must be acceptable.
 This is *the requirement for ease and economy*.
6 The appearance of the device must be acceptable.
 This the *the requirement of appearance*.

Design, in all its fields, is the profession of satisfying these requirements. The architect, however, has the additional task in effect of inventing the objects before he begins (Chapter 10).

The question we have to consider is: how far, if at all, does each of these requirements limit the designer's freedom of choice?

The first requirement, that the design must correctly embody the essential principle of arrangement, has already been touched upon (Chapters 1 and 2).

Various aspects of the arrangements of mechanisms are dealt with in the science of kinematics, which deals with motion or holding still without reference to force and mass; that is to say it concerns itself with the movements of the components of devices but not with their strength or substance. It is a first principle of kinematics that mechanisms which are kinematically identical may be dissimilar in appearance: which amounts to saying that although the mechanisms are of different shapes they may share the same essential principle of arrangement. The functionalists presumably did not hold with kinematics, or perhaps

Fig. 5

considered the function of a mechanism to be independent of its motion!

Neither in textbooks of kinematics nor in patent specifications are essential principles of arrangement stated in very general terms. The essential principle is ultimately concerned only with the capability of the things in the system to transmit forces of as yet unknown strength to the desired places and in the desired directions, and to modify them as desired. This capability depends on the arrangement of the things. But any statement of the essential principle is above all a general statement, and must therefore be concerned not with the arrangement of particular things but rather of things of certain classes. Although the classification is in fact based on the way the things transmit and modify forces, one would hardly think so when reading a statement such as that on page 19. The terms used appear to be particular and not general; and moreover they appear to define the shape of certain components rather closely. In such supposedly general statements as this we cheerfully talk about 'a pin', 'a rod', 'a hook', 'a cup', 'a wheel', 'a retort', 'a wedge'.

Let us suppose that such terms do in fact describe shape. Let us take the term wedge. What shape is a wedge? All the things in Fig. 5 are wedges. But which is *a* wedge? What indeed is a hook, a pin, a wheel?

Whatever else such terms refer to they do not refer to individual shapes. They are in fact terms referring to a class of arrangement of the matter within single things. A single solid thing, after all, is merely a slice of space with a few billion separate particles of this kind and that tottering about inside it. When we say a wedge we are indicating something about the way they are arranged. We are specifying a one-component system in fact. A fairly intricate device such as a safety-pin can be made of a single thing – a continuous wire – or, if desired, of several things.

The only way of closely defining the kind of arrangement of matter which we call a wedge or a hook would be by referring to the way it transmits forces. A hook will pull. A not-hook won't pull. Shape, individuality, doesn't come into it.

Shape, for us, is what gives individuality to things. All of us are extremely expert in recognising the individual character of shape in closely similar things such as human faces and hands of writing. The individuality of shapes is the stuff of art, whether in design, painting, or any other field. It is our present concern to find out how far the designer has freedom to give devices a chosen character of appearance, of shape. The essential principle which he must embody in the device

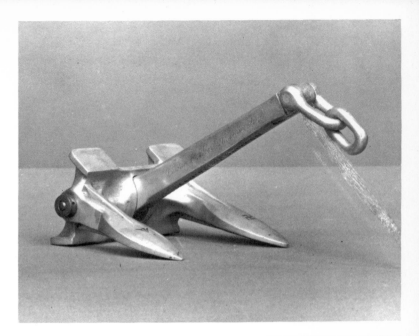

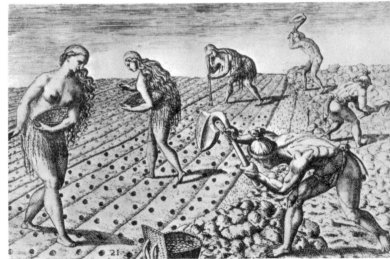

'Hooks'. Anchor and American Indians hoeing a seed-bed (engraving by Theodore de Rey, 16th century)

he is designing sets limits merely to the extent that if the principle requires 'a hook' then not-hooks are excluded. But there is precisely an infinite range of possible shapes for a hook. The limitations on freedom of choice, so far, are nugatory.

The second requirement of those we enumerated, that the geometry shall be what the particular result entails, sets limits to the designer's choice of shape in ways which are best illustrated by a detailed example, and this will be found in the next chapter. It will be seen that the limits leave still an infinitely wide freedom of choice in the matter of shape.

It is worth noting that the essential principle of arrangement of every device was abstracted from, and is a generalisation based on, the first embodiment of the invention: an embodiment which, being real, had a particular geometry entailed by particular objects and a particular result. It is not always easy to make a true generalisation, separating the essential arrangement from the incidental geometry. This fact may have contributed to support the belief in 'functional' design. Because we visualise particular things, and can never visualise anything but what is particular, we fail to realise what an enormous latitude in choice of shapes we normally enjoy.

It would be most interesting to know the history of the idea that any device embodies an essential principle and so can be adapted to other results and objects than those in the first invention. There can be little doubt that this idea has sometimes been repugnant.

The third requirement is that the components must be strong enough to transmit the forces or resist them. The forces involved will originate both from the intentional input of energy as the system is used and also from unwanted sources of energy, in particular gravitation. This requirement obviously affects the size of each component, and in combination with the first two conditions, the essential principle and the geometry, it may begin to shove the designer in the direction of one shape rather than another. But in these days we are apt to forget what a very slight restriction on shape the calculation of structures does actually impose. This is because we take it for granted first of all that the minimum amount of material ought to be used (a cheese-paring attitude which fortunately did not hold in, for instance, Rome, Athens, Venice, Chartres, and a few other places), and because we habitually use standard prefabricated components when making structures. The fact that you have calculated the minimum cross-section necessary to a member such as a column need not often prevent you from making it any shape you like.

Until very recent times, experience and rule of thumb based on it were the only things which could help a designer to decide what sizes the components of a system would need to be in order to give them

adequate strength. In many trades, still, no other aids are used. But since exact methods of measuring changes have been evolved it has been possible to predict accurately what sizes will be adequate. The train of thought is of the form, 'We know that one unit of this stuff will support two tons. We want to support eight tons. How many units do we need? Four.'

Wise after the event, we may feel that our ancestors were rather slow not to have thought of this. But even if they had wished for something more trustworthy than their own experience as a basis for prediction – which doubtless they did not – the train of thought above described is not the whole story. You have first to establish that one unit of the stuff supports two tons.

Suppose that you take a one inch cube of some material and increase the load until your cube begins to crush, and suppose that when it does you find that the load is two tons. You may quite possibly then expect, a two inch cube, containing eight cubic inches, to support eight times as much, namely sixteen tons. But you find to your surprise that it supports only eight tons, or four times as much. You may then conclude that what matters is the area of the stuff in contact with the load: load 8 tons, area 4 square inches, 8/4 equals 2 tons per square inch of area in contact. But of course you are still wrong. The area in contact has very little to do with it. It is easy for us to see this but it was not easy for the first man who did that kind of experiment. He had to think it out, or perhaps, poor man, find it out. Moreover the strength of a material in compression is really a comparatively simple sort of thing to measure. Furthermore materials with uniform properties were not common in old days. The strength of timber is not a thing one can be sure of even now, however carefully it is graded. Experience or caution will influence decisions in which it is involved.

In order to take the design of any structure even to the stage of a sketch the designer must first assume, roughly, the sizes which each part will need. Nowadays we shall verify these by calculation. In old days we should have been obliged to do so by trial. But we, like our ancestors, can only design if we are capable of making reasonable preliminary assumptions based on experience. There is no other way. The difference between their proceedings and ours is in the method of verification of the assumed sizes, not, at this stage, in the method of designing. Design always involves making trial assumptions based on experience. These may appear on paper or be carried in the designer's head. But the process is essentially a process of trial and error however

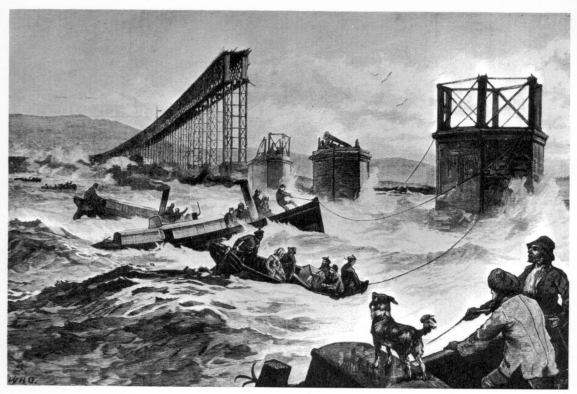

The Tay Bridge Disaster, 1879

*Illustrated London News. Mansell Collection*

the assumptions are verified, and this applies to many other assumptions besides those we make about strength.

It must be emphasised that design, of every kind, is a matter of trial *and error*. There are always some trial assumptions which no calculation or drawing can verify. Men can not foresee the future. Design, like war, is an uncertain trade, and we have to make the things we have designed before we can find out whether our assumptions are right or wrong. There is no other way to find out. When we modify our prototype, it is, quite flatly, because we guessed wrong. It is eminently true of design that if you are not prepared to make mistakes, you will never make anything at all. 'Research' is very often a euphemism for trying the wrong ways first, as we all must do.

Science has enabled us to make a few of the advances in technique which are obviously desirable, and these we shall presently discuss. It

# ROYAL GARDENS, VAUXHALL.

# GRAND DAY FÊTE,

## On MONDAY, the 24th of JULY, 1837.

### Extraordinary Novelty and Combined Attraction!

# ASCENT IN THE ROYAL NASSAU BALLOON

## BY MR. GREEN,

### AND DESCENT IN A NEWLY-INVENTED

# PARACHUTE,

## BY MR. COCKING.

The Proprietors of Vauxhall have the satisfaction to announce that they are enabled to present to the Public another grand improvement connected with the Science of Aerostation; viz. a PARACHUTE of an entirely Novel Construction, by which a perfectly safe and easy descent may be made from any height in the Atmosphere attainable by a Balloon.

Mr. COCKING, a gentleman of great scientific acquirements, having, many years since, witnessed the descent of M. Garnerin, (the only one ever made in England,) was forcibly struck with the danger to which that gentleman was exposed on account of some error in the construction of his machine; and, after several years spent in numerous experiments, has succeeded in discovering the faults in M. Garnerin's instrument, and also in producing

## AN ENTIRELY NEW PARACHUTE,

which is allowed by all who have seen it, to be constructed on unerring principles. The form is that of

## An Inverted Cone 107 Feet in Circumference!

which, during the Descent, is quite free from oscillation; and as it will be in its proper form previous to the Ascent, it is not liable to the objection of falling several hundred feet without expanding, which was the case with the Parachute of the old form.

## MR. COCKING WILL MAKE HIS FIRST DESCENT
### ON MONDAY NEXT, JULY 24.

The great power of the Royal Nassau Balloon has afforded the means of making an experiment with the above-named Machine, which, from its great weight, would be impossible with any other Balloon hitherto constructed.

The plan adopted by M. Garnerin was to ascend alone and detach the Parachute from the Balloon, which having no person to conduct it, fell in some very distant part, and was either lost or destroyed; but Mr. GREEN has undertaken to ascend in the Nassau Balloon, and to liberate the Parachute himself, a feat never before attempted by any Aeronaut.

### THE PARACHUTE WILL BE EXHIBITED PREVIOUS TO ITS ASCENT.

In order to render this Fête more than usually attractive, the Proprietors intend giving a variety of Amusements during the Afternoon, the principal of which are—

**A CONCERT in the Open Orchestra**
**A DRAMATIC PIECE in the Theatre, which will be lighted as at Night**
**The Extraordinary Performance of M. LATOUR, M. DE LA VIGNE, & their Sons**
**THE YEOMANRY AND QUADRILLE BANDS, &c. &c. &c.**
### AND A VARIETY OF OTHER ENTERTAINMENTS.

## Doors will be opened at One; & the Ascent at Five.

The Descent will be made as nearly over the Gardens as possible.—ADMISSION, 2s. 6d.
### VISITORS ARE REQUESTED TO COME EARLY.

☞ The Admission to the Evening Entertainments will be as usual.——Parties can Dine in the Gardens.

[Balne, Printer, 38, Gracechurch Street.

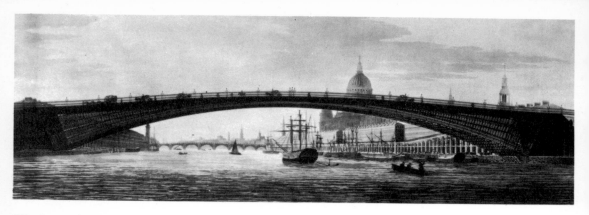

'The larger they are, the lighter'. Thomas Telford's proposed cast iron bridge over the Thames, 1801

*Crown Copyright, Science Museum, London*

has not enabled us to predict the behaviour of people; which very many designers urgently need to be able to do. It has not enabled us to foretell what *will actually happen* in any particular case. It has enabled us to make better predictions about responses than our forefathers could make, but our predictions are still pretty shaky. We can not design a new spacecraft, or a railway train which does not rock, and get it right first time, nor yet second time. We design failures because we can not make reliable predictions about responses. Nor do we in fact rely on them. We rely only on trial and error, or as we euphemistically say, on experience. If scientists had as much foresight as is sometimes believed we should no longer have to rely on experience and could rely on them instead!

When a device is so designed that its component parts are only just strong enough to get the intended result without danger of failure, we may say it is in its minimum condition. This condition may be sought for other reasons than direct economy of material. In a large bridge, for example, the main problem may well be to make it carry its own weight. The traffic will be a mere flea on its back. Consequently every part of the bridge must be as small as possible consistent with its doing its work. The bridge must stand up, but only just. It is the small bridges which are massively built. The larger they are the lighter they usually seem, and are, relative to their size.

It is a fair guess that arrows were the first things ever designed for a minimum of weight.

I suspect that the functionalists sometimes meant by functional design simply design aimed at the minimum condition for a device. In that case 'form should follow function' would mean that every

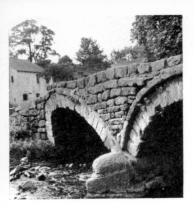

Bridge at Wycoller, Yorkshire

*British Railways Board*

system should be in its minimum condition, thus having certain limitations imposed on its form.

To say of most buildings that they shall be in their minimum condition is no more and no less arbitrary than saying that they shall be in the Corinthian order. Neither *diktat* has any bearing on how well or ill they do their job. If the system is in any adequate condition – and one adequate condition is the minimum condition – then it produces its intended result whether in the Corinthian order or not. It may be argued that the minimum condition is more economical. In houses it most certainly is not. The workmanship, research and calculation needed to design and achieve it will cost far more than the material saved.

In engineering on the other hand the minimum condition may really be worth having for the sake of economy in cost or in energy at work. But what applies to it does not apply to houses.

Among the shapes most often called 'functional' are those streamlined shapes which appear in parts of devices which penetrate things, for example a ship's hull under water, an aircraft, a spear head, some projectiles, an axe.

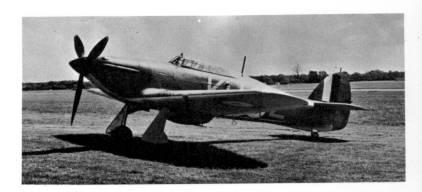

Hawker Hurricane

*Crown Copyright, Science Museum, London*

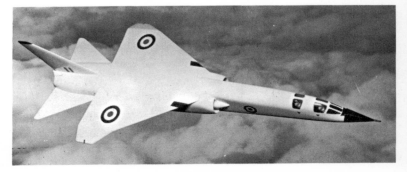

TSR-2

*Crown Copyright, Royal Air Force*

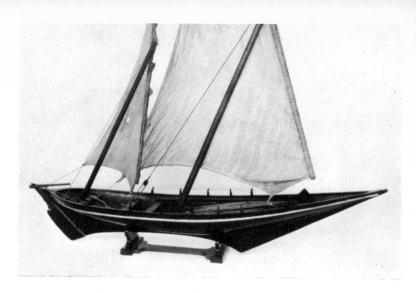

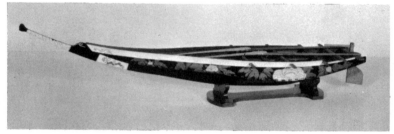

'Devices which penetrate things'.
Bombay Maschura and a Japanese
whaling sampan

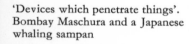

*Crown Copyright, Science Museum, London*

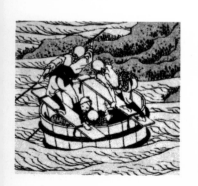

It is not easy to penetrate solids and fluids at any considerable speed. There are too many unwanted resistances in the response. When a minimum of resistance is required the geometry becomes very exacting and imposes very close limits to the designer's freedom of choice. There is not too much difficulty in getting any old shape of ship through the water at one knot, but some kind of immense wash-tub propelled at thirty knots will produce a very awkward response and take a vast amount of energy. If high speed or easy penetration is required then the unwanted parts of the response must be reduced to a minimum.

But in these designs, as in all others, compromises are invariably made. The visible shape of a streamlined craft depends as much on what you have chosen to streamline, i.e. to put inside it, as on the laws of nature. Every make of aircraft differs in shape from every other.

These 'functional' shapes designed for a minimum of change in the way of shifting air or water are as much chosen shapes as any other,

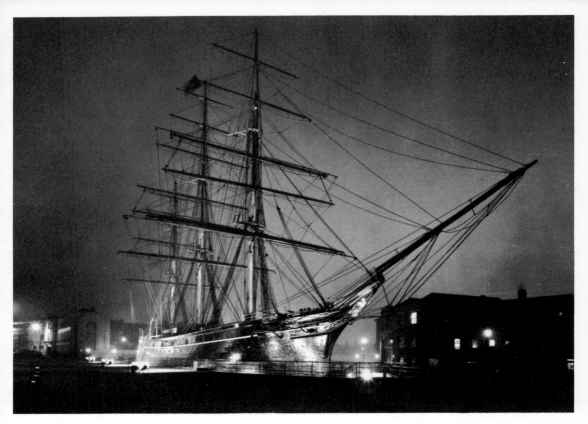

'Cutty Sark' in her drydock
at Greenwich

*Photo, The Times*

and a minimum condition is as much a chosen condition as any other adequate condition. The reasons for the choice may be economic or aesthetic or defensive or silly or doubtless of many other kinds.

The fourth requirement of use is that for access. We think of a device as a self-contained system, but of course no system is self-contained. Every device is a subsidiary part of a more extended system (which must contain among its other components, man). Since any device will have to become a component of a larger system or of several in turn, its geometry must be suited not only to its own proper result but also to the result of the extended system or systems. It follows that a prime requirement in the design of many devices is accessibility. The quay must allow the crane access to the ship's hold. The ship must draw no more water than covers the sill of the dock. The engines and their accessory devices must be disposed so as to allow easy access for the

'Access'.
San Francisco
Airport

*By courtesy of USIS*

engineer's hands when he is maintaining them. The most familiar require-
ments for accessibility occur in buildings, and the art of planning them
in its utilitarian aspect is largely concerned with affording the users of
the building easy access to the several parts of it (Chapter 8). Things
do not invariably get in each other's way and access is sometimes so
easily provided that the requirement is never noticed; but it can in
other cases be most difficult to satisfy, for the most characteristic
quality of modern devices is their complexity. Where there is complexi-
ty, requirements for access become difficult to satisfy, and impose
distinct limitations on the designer's freedom of choice, (or, in some
motor cars, evidently defeat him altogether).

'The mark of economy in, literally, every stone' The Erechtheum

*Greek Government Tourist Bureau*

The ultimate causes of complexity in devices nearly all lie in the requirement for ease and economy, but to trace the immediate causes and distinguish in principle the various very different ways in which they take effect would be a considerable undertaking. There is for example a clear distinction in principle between a mechanism and a mere aggregation of systems. A mechanism is a combination of distinct systems, but the result of each entails that of another. A thing like a stove is also a combination of distinct systems, but here although the result of one may or may not affect that of another, the result of none entails the result of another. One could remove the entire system for riddling the ashes and the entire system for regulating the draught, and still one could get the intended result somehow. There is no essential principle of arrangement for the systems *inter se* in an aggregation like a stove; but in a mechanism there is. A mechanism is one system built up of systems. Most mechanisms however show an accretion of palliating systems also, such as anti-friction bearings and lubricating systems which could be omitted without affecting the essential arrangement of the system.

The fifth requirement, that for ease and economy, has very wide implications.

Theoretically it is possible to design for a result without the design being influenced in any degree, either directly or indirectly, by economy. In practice this does not happen. As will be seen (Chapter 5) the most lavish and magnificent buildings show the mark of economy in, literally, every stone. The influence of economy in design is universal. But economy here implies something more than saving money.

Any change originated by man exacts a cost from him. The cost is reckoned in effort, trouble, time, often in running risk and enduring discomfort also. Adam found this out. 'Economy' as used in the present essay must be understood as referring primarily to this unpleasant catalogue and only secondarily to the money which we pay to avoid enduring it; for when we pay a price in money for a device, as a rule we are paying directly or indirectly to escape the natural cost in effort or discomfort, trouble, time or risk, of the result which the device gives.

The great majority of devices simply enable us to get cut-price results. There are really rather few devices which make it possible to get results which without them would be unattainable. The only such devices in the realm of transport, for instance, are the vessel, the raft, the aircraft, hovercraft and rocket. No form of land transport qualifies;

'One can walk'

* The Waste Makers

all are merely palliative. One can walk.

Economy is the mother of most inventions, not necessity, unless in the sense of poverty and hardship. A requirement for convenience is simply a diluted requirement for ease and economy. It is true that much convenience is an idiotic sort of economy but it is quite impossible to draw a line between saving labour, sensible convenience, and the idiotic 'convenience' catered for by the waste making economy which Vance Packard has so well and horrifyingly dissected.*

The consequences of the search for 'improvement' in devices are manifold. Perhaps the most obvious consequence is seen in the engineer's preoccupation with producing machines of higher efficiency, with less waste of power in friction; and in the importance in most manually driven machines of a high mechanical advantage; for we would all rather use a long lever than a short one. Such good engineering in the service of economy does impose limitations on the designer's freedom of choice of shape, but only very loose ones, for they mostly affect size alone. The lever is a fair example. The fact that you must make it long prevents you only from designing something short and thick while it leaves you an infinitely wide choice in other directions.

The more remote consequences of the search for cheaper results exert much more effective limitations than these; but the limitations which result from cheapening the manufacture of a device are far and away the most stringent of any. A low retail price in the shop often overrides every other consideration in design.

The requirements of use are imperative. If they are not complied with the device does not give the result. The requirements of economy are on a different footing, for the amount of weight given to them is a matter of choice.

All possible useful results except transformations of energy are shifts – shifts of particular things, large or minute, over particular distances in particular directions. The things, the distances, and the directions are legislated for by the requirements of use. But the speed of shift, the energy needed to produce it, the amount of energy wasted in the process, the unwanted changes which accompany the shift, the labour or distress exacted from people, all these are legislated for by the requirement for ease and economy.

*It seems to be invariably true that those characteristics which lead people to call a design functional are derived from the requirements of economy and not of use.* I have found no exception. Streamlining, omission of ornament, exposure of structural members, 'stark simplicity', all of these derive

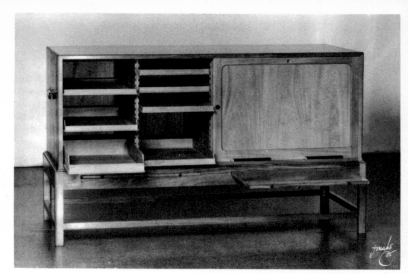

'All the qualities of appearance which decent workmanship produces'.
Sideboard designed by Kaare Klint

By courtesy of Rud. Rasmussens Snedkerier, Copenhagen

directly or indirectly from requirements of economy (which is not to say that they do in fact give economy!). A result, though not always at an acceptable cost, can always be got without these characteristics. They are inessential. In some cases indeed they are as much features of style as any overt system of ornament.

A thing may be called 'purely utilitarian' if it is designed so as to comply with the requirements of use, and of ease and economy, but ignoring the requirement of appearance. No such thing really exists; for nothing can be made without some concession, however slight and unwitting, to the requirement of appearance any more than a human being can be entirely amoral.

Work done solely for the satisfying of the requirement of appearance may be called 'useless work'. Useless, of course, does not mean worthless.

The sixth condition is that the appearance of the device must be acceptable. This conflicts headlong with the requirements of economy and it is heartening to see how so many designers and manufacturers consistently expend useless work on satisfying it. Smoothness and all the qualities of surface finish, flatness, straightness, fairness of curves, neat fitting, neat detailing at junctions, all the qualities of appearance which decent workmanship produces, are to be seen still in immense numbers of the things of all sorts which men make; and almost all of these graces could be omitted or made worse without any loss of

effectiveness in the devices which exhibit them. They are taken so much for granted that one would think people supposed that they were achieved automatically. No credit for them is given where credit is due. There is no realisation that they are an affair of art, and not less important than design in the large, for without them the best of design is entirely wasted so far as appearance goes. A surprisingly large proportion of manufacturing time in nearly every field is in fact taken up with useless work catering for the requirements of appearance.

The requirement of appearance imposes very distinct limitations on the designer's freedom of choice of shape in the large. This is done through the medium of styles of design, which confine him to a fairly narrow canon of shapes. It can be argued that design has invariably exhibited styles because some clear limitations on freedom of choice are psychologically necessary to nearly all designers. When design gets too easy it becomes difficult. Styles provide these desired limitations when, as so often, the requirements of use and economy do not impose limitations which are close enough. But for lack of space the argument cannot be developed here.

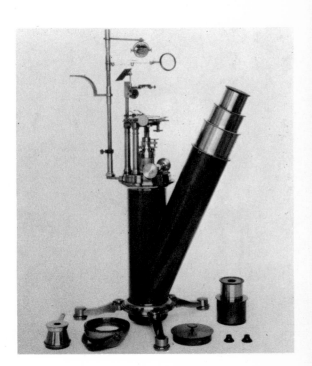

Inverted microscope, Nachet & Fils

*Crown copyright, Science Museum, London*

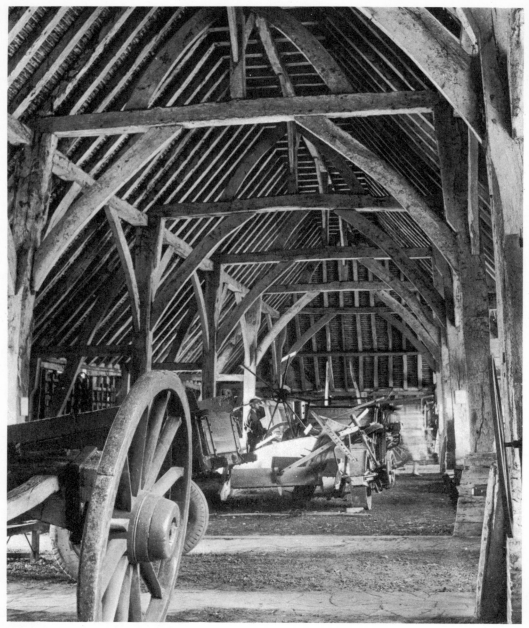

'The qualities of appearance which workmanship produces'
Barn at Cressing Temple, Essex, built in 1480.

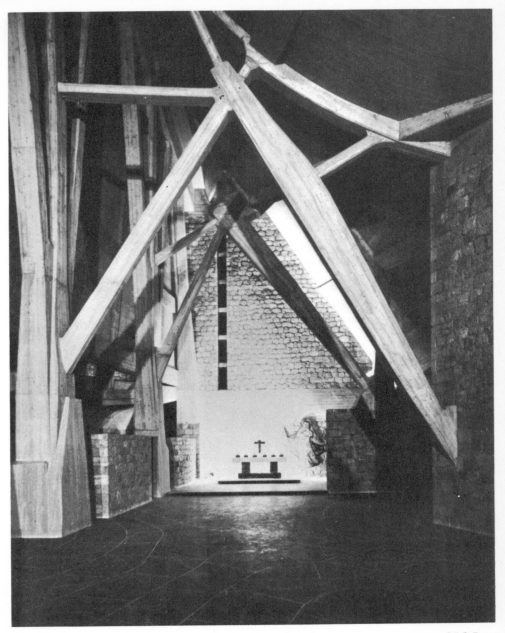

'The qualities of appearance which workmanship produces'  *I.R.I. Rome*
Church at Campi Bisenzio, near Florence, designed by Professor Giovanni Michelucci

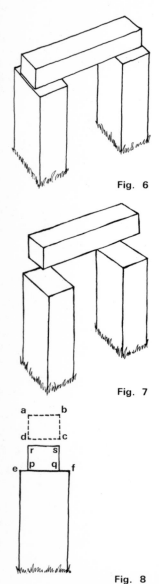

Fig. 6

Fig. 7

Fig. 8

This chapter explains in detail how the second of the requirements of use, that the geometry of the system shall suit the particular result intended, affects the appearance of the design. It also continues the discussion of invention.

Suppose that by the use of a lever we intend to raise a beam already standing on two piers. We want Fig. 6 to become Fig. 7, using blocks to hold the beam up another foot and a half (or cubit, by the look of the picture!). We propose to do this with a lever, by adding that to the existing system. Fig. 8 shows the existing system end-on, and the intended new position of the beam in dotted lines. Now if we simply get a lever, shove one end under the middle of the beam, take care that the fulcrum is below the lever, and sit heavily on the other end, it will be a remarkable bit of luck if the beam shifts from PQRS to ABCD. It will probably shift, if it shifts at all, from PQRS to almost anywhere else. Embodying the essential principle of arrangement is, by itself, no guarantee of getting any particular intended result. In fact we shall find, by trial and error, that no lever can ever shift the beam to position ABCD. It is impossible. But we may be inspired to realise that a lever system can be used to shift the edge of the beam, its arris, to position C and that if we do this and slip in the blocks below the beam when we have done so, it will fall to position ABCD, turning as it does so, when we take away the lever (Fig. 9).

We therefore decide to achieve the end result by way of an intermediate result. Now for this particular intermediate result, which is the beam shifted from position PQRS to position JGHC, Fig. 9, we shall have discovered that the geometry is fairly exacting. The fulcrum, for example, must be in a line which bisects the line CQ at right angles. If it is above this line the arris Q will be shifted to the left as it rises up; if below this line it will be shifted to the right; and in neither case can it reach the point C.

Now a lever cannot be a line. It has thickness. But in the new configuration of the system the base of the beam will be lying on the top of the lever, and the fulcrum must lie in the same plane as that. Hence the lever must be cranked or shaped like a dog's hind leg (Fig. 10). The geometry has begun to impose limitations on the shape of the system.

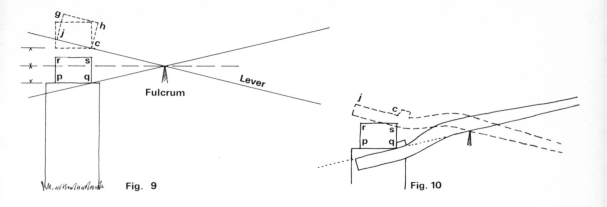

Fig. 9

Fig. 10

But the limitations are by no means severe, for the shape of the lever between the beam and the fulcrum can be almost anything, so long as it allows the fulcrum to lie in the line JC produced. It cannot be straight, but it can be of an infinite variety of shapes, and have dragons and small coils of rope carved on it if so desired.

The process of design which has produced it is trial and error – conducted in imagination and with the aid of drawings. There is no other way of arriving at it. However skilled the designer may be, he can only discover what geometry is needed by making assumptions, that is to say, imaginary trial arrangements. In this case however he can verify most of his assumptions by using theory, namely his knowledge of geometry, instead of actually building a trial prototype of the device.

I had intended to end the discussion of this example here. But having written the preceding paragraphs with the system in my mind's eye and illustrated only by a scribble in the margin, I thought it would be as well to make a more complete sketch of it as a memorandum for Figs. 6-9 which I should have to draw sooner or later. I accordingly did so, and was annoyed but not much surprised to find that I had overlooked something. The system as I had described it would not, in all probability, give the intended result; for when the lever starts to lift it touches the arris of the beam Q which from that time onwards must remain in the same place on the lever which it first touched, otherwise it will never arrive at C. But that point on the lever will swing through an arc of a circle convex towards the left of the picture as the beam is lifted (Fig. 11); while if the beam pivots, as it must, on

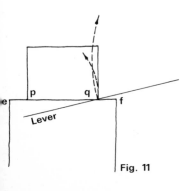

Fig. 11

the arris P during the early part of the lift (at which time only the other arris Q is in contact with the lever) the beam rotating about P will swing through an arc which is convex to the right. Consequently either P must slip to the left on top of the pier or Q must slip to the right along the lever. We cannot allow the latter, because if Q slips at the start it cannot reach its intended position at the finish. Therefore we must insure that P slips to the left, or else insure that the beam is lifted off without rotating, by cranking the lever still more (Fig. 13).

I thought, when I saw this, that for purposes of illustration, it would be better to abandon this example, which was a rather far-fetched concoction at best, and was getting complicated by too many snags, so that it would not bring out the important points as I had intended. But designing is delightful, while thinking of apposite examples and carefully describing them is hard work. So it came about that rather than get down to the hard work, I started without any conscious intention of doing so, to redesign the system so as to eliminate the snags; and it was soon done. When I had done it I thought that this after all was a good example to use, because I could describe the fairly typical train of thought which I had just gone through and thereby show something more about the nature of design.

The train of thought went somewhat as follows: 'Here is the difficulty of the intersecting arcs, and it is not going to be the only one. As the picture stands (Fig. 10) the beam is real and pretty heavy, the fulcrum is a mere notion of a knife edge floating in the air, and the lever is something between a diagram and a bit of wood, a bad bit of wood at that. If it happens to have been grown to that shape it will do the job, but it will take a long time to find a grown crook like that and the time will cost too much. But if it is made by cutting it out of a plank – supposing we can get a sound one large enough – it will be short-grained and weak at the crook. What is more the fulcrum looks horrible. The lever will ride about and slip when we up-end it. The whole thing looks horrible and why on earth don't we use a hoist? Because we are writing a book. Then what can be done with the lever? A block fixed at Q will prevent the beam slipping to the right. So P will slip to the left. So there will be a horizontal thrust on the pier trying to push it over and likewise on the fulcrum trying to push that over in the opposite direction. But the fulcrum will be on some sort of trestle, and we could shore up the pier if necessary (and it will not be necessary) so we can take care of the thrust. But the beam will not slip on the piers any too easily. We are picking it up at the middle of its length. If it

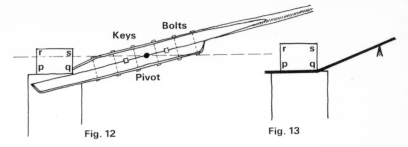

Keys    Bolts

Pivot

Fig. 12            Fig. 13

slips on one pier and not on the other it will slew round. And what if both ends stick? But we can lift it slowly and have men with crow-bars to edge it along so that both ends do slip, and slip together.

Then the lever will look like Fig. 10 and will not be any the better for it, in our opinion.

At this point we have the familiar brain-storm which is the special fascination of designing. We see – not think out, but see, all complete – a way of eliminating all the difficulties in one move and making a workmanlike looking job into the bargain. What we see is Fig. 12. The lever is made up of two squared timbers held together by bolts (we afterwards substitute iron straps round the timbers). There are cross-grained hardwood keys in case the timbers try to slide along each other. There is a hole bored through which will take the fulcrum. The fulcrum is to be a cylindrical steel bar making an easy fit in the hole, in fact a pivot. Thus the necessary arrangement is provided for; the fulcrum is in the right place. The block is provided by the end of the upper timber, and the lever has its strength where it needs it most – near the fulcrum. All this we seem to see, suddenly, without conscious thought as a preliminary. We have killed all the birds with one stone.

The thinking has not been conscious, but it must have been done; for this design, like the analysis of the difficulties which preceded it, is evidence that we have a considerable knowledge of the kinds of response which occur in lever systems. We know the lever will bend. We know it will tend to bend most at the fulcrum. We know too that if the fulcrum is to be a pivot penetrating the lever, then the best place to make the hole is midway between top and bottom. In that place the lever will be very little weakened.

We know all this, and know that we know it. The design has evidently been somewhat informed by this knowledge. But this is not the only design which would work. It is safe to say that no two designers using timber would design the lever in quite the same way. Making a

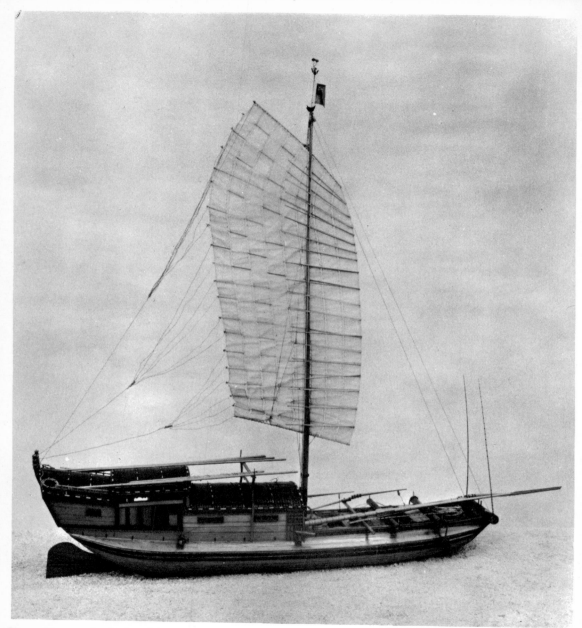

Upper Yangtze Junk. A yuloh can be seen on deck

*Crown copyright, Science Museum, London*

doubling round the fulcrum was certainly not in our head when we set about designing the lever. I cannot swear to that. I cannot be sure that I have never seen such an arrangement. But I am certain that I did not have that idea consciously available in the same way that my rather imperfect recollection of the theory of beams was consciously available.

Where then did the idea of the doubling round the pivot come from? There is a certain element of invention or creation in the idea. Joining timbers by lapping or doubling is commonplace. Pivoting timbers on a bar through the middle is commonplace. But the idea of making a joint in a lever precisely at the point where it needs most strength is by no means commonplace. Moreover the act of neatly killing several birds with one stone, as we have done here, is not commonplace. It is in its degree ingenious.

But I do not believe that this or any such ingenuity is unprompted. Invention involves an antecedent of some kind.

In the present instance, when I set out to trace in my unconscious mind the antecedent for the doubled lever I found that there was persistently in my mind's eye a picture of something not only doubled but also crooked (Fig. 14). I realised that this was probably a recollection of an oar, called a Yuloh, used in China for sculling Junks and Sampans by the stern. The analogy then became apparent. The Yuloh, being an oar, works like a lever. It has a doubling in it which serves to make it crooked, *and it is pivoted at or near the doubling.* It is pivoted in a different way from our lever and produces a different though analogous result. The 'creative' act was the unconscious selection of the Yuloh out of all the innumerable devices stored in a designer's memory, as an analogous device to this very different lever. Fig. 14 shows a Yuloh.

It is of course possible that I have unconsciously produced the Yuloh as a cover for unconsciously lifting someone else's invention of a doubled lever (which would be pretty ingenious in itself!). It is also possible that this way of working is a personal eccentricity of mine. But I do not believe in either possibility. I believe that this is the normal process of 'creation'.

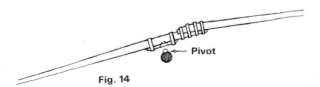

Fig. 14

45

We have briefly considered how far the shape of things we use is influenced by the requirements of use and economy and access. We must now consider the influence of technique. In doing so we shall find that the influence on shape of technique, *per se*, is small. Nearly all the so-called technical limitations on design are limitations not so much of technique as of material or, once more, of economy. We must distinguish between 'limitations' set by our unwillingness to incur work and trouble on the one hand, and real limitations set by our inability as workmen on the other. A competent workman nowadays may fairly say to a designer, 'Design what you like in the material I use, and I can make it, no matter what its shape may be'.

We are so reluctant to acknowledge that economy has been a major influence on the design of even the most splendid things which men have made, that we often say 'better' when we mean 'cheaper'. 'Work Study' is double-speak for Cheapness Study. Its basic principle that there is one best way of doing any operation in a factory, is untrue. It may well be true that there is one cheapest way.

Our insistence on doing useless work is continually in headlong conflict with our insistence on economical technique, which is simply the elimination of useless work. It is a most diverting spectacle to see the experts in work study exercising their considerable ingenuity to find the one cheapest way of doing operations which could perfectly well be dispensed with; for example, getting shiny surfaces on furniture. The 'one best way' of doing things like that is not to do them.

A technique embraces a group of systems which cause some specified change in the characteristics of pieces of material – any material.

Any material has certain characteristics – hardness, strength, ductility, stiffness etc. – and a certain amount of each is peculiar to any given kind of material. But material as such does not exist. Only things, *pieces* of material, exist. Man's earliest essays in using things were doubtless made by using the pieces of material as he found them. He had no techniques with which to alter either the characteristics of the material such as hardness or strength, or the characteristics of the piece, such as shape and size.

We no longer have to take the characteristics of the piece as we find them. We have by now several effective techniques for altering these: wasting, forming, casting, and constructing. But we still have to take the characteristics of the material much as we find them, for we have not yet any thoroughly effective techniques for altering these, for processing materials.

Processing material means altering its properties, as in smelting or in hardening steel by heat, or making wood-wool out of wood, or fibre out of glass, or powder out of a solid, or cement out of mud. Wasting techniques are those which involve carving away a piece of material until the shape you want remains. Sawing, milling, planing, turning, punching, are examples. Construction means making a whole out of parts, by connecting them. Connection may be by interpenetrating, as in a carpenter's joints or a rivetted joint, or by interlocking, as in spinning or weaving, or by welding, or by jointing with an adhesive. Forming means changing the shape of a piece by bending, pressing, forging, etc. Casting means pouring a liquid into or over a mould, which liquid subsequently hardens having taken the shape of the mould. Polishing is hardly a separate technique according to the usage here since it is a combination on a minute scale of wasting and forming (or, put another way, the function of a polishing tool is abrasion and melting).

As things stand today the second and third of these techniques are very highly developed. It is almost true to say that one can cut any shape out of any material, and join anything to anything. The fourth and fifth techniques are also highly developed where they are applicable. But their application is limited because the first technique, processing, is still rudimentary.

The only considerable technical limitations on design are imposed by our ineptitude at processing material. We are still obliged to take most materials as we find them with all their natural properties and to improvise things out of what we find. In primitive woodworking one looked for a branch or root already grown to about the shape one wanted. With our primitive processing techniques we are obliged to do likewise in selecting materials. The technological advances of the next* age will be in processing. We already see forerunners in our synthetic and reinforced materials. A material such as nylon is a solid refutation of the idea that synthetic is synonymous with inferior or substitute.

Meanwhile for lack of adequate processing techniques we are limited

* Perhaps rather of the present age. Already (1967) the word ineptitude begins to look too strong.

47

to materials which have fixed, arbitrary, combinations of properties. One can have a material which is hard, tough and stiff but only if it is also heavy, cold, opaque, and liable to rust – steel. One can have a material which is immune to rust, and is light and warm, and which is still fairly hard, tough and stiff, but only if it is unstable – wood. We can nearly always find some material with the one property we want, but we have no control over the concomitant properties of it; in other words over the total response. The truck agreement which compels us to take properties we do not want along with those we do applies particularly in technique. We can vary the tensile strength, say, of a component exactly as we wish, by first selecting a material which has fair tensile strength and then proportioning the cross section of the component to the tension force in it. What we cannot do, is to vary the other properties associated with the material we have chosen. The thicker we make the component the heavier it gets, but we should like it to get lighter as it gets thicker. What we need are processing techniques which would enable us to vary properties of components independently of each other, and other techniques to vary them locally without altering size and shape. As things now stand our poverty in such techniques compels us to control the strength of components largely by varying size and shape. Deficiency of technique is here a real limitation on the

48

shape of things, even though in practice not a very severe one. It seems unlikely that this deficiency will ever be entirely made good.

There is also a serious deficiency in techniques for preventing corrosion and other such unwanted changes: again a deficiency in processing. Why should metals need coating?

The choice we make among our present range of materials may be directed both by knowledge of the responses associated with them, and in many devices by the sizes in which the materials are obtainable.

Between the remaining four kinds of technique there is very little we cannot do. We cannot drill a serpentine or spiral hole but we can make one by casting or constructing. Cutters, abrasives and flames of various kinds will get through anything we know of, and we can control them. These techniques are inept only in respect of size. We cannot handle mountains or molecules at all well. We can cut accurately to a ten-thousandth of an inch or less, but we can do nothing effective with any piece of material unless it has at least one relatively large dimension. Nor can we do anything effective with very large pieces. The technique of construction has been built up partly to make up for deficiencies in wasting, casting and forming techniques, but obviously very much more to circumvent our difficulties in handling large objects.

We may say then, as a fair generalisation, that wasting, constructing, forming and casting techniques taken together are so versatile that they impose, *per se*, hardly any limitations on the shape of what can be designed, but that they do impose limitations on the size of it.

The influence on shape which is exercised, not by technique, but by cheapness of technique, is enormous, and particularly so in the field of construction, which we shall consider first.

A flat surface will touch any other flat surface at all points. No other shape of surface will touch every other surface of similar shape at all points. A hemisphere, for instance, will only touch a hemispherical hollow at all points if it has the same radius as the hollow hemisphere; i.e. if the surface is of the same size. The flat surfaces need not be of the same size. Thus a mason building a wall need not fit each stone he lays to the stone below it. Having cut all his stones to flat surfaces first, he knows that any stone will bed steadily on any other without having to be fitted to it individually.

The versatility of flat surfaces is not commonly seen in nature. Stones which cleave under frost exhibit it; but the breadth of its application was a discovery of man's, and one of his most valuable, for it enabled him to reduce the cost of construction in all materials very considerably.

49

An extension of the discovery was that if the components of a structure were 'squared', i.e. were given two flat surfaces at right angles, then they would not only touch each other at all points of the adjacent surfaces, but would also both do the same to a third component.

We take all this very much for granted. Any house and its contents, and the toy bricks on the nursery floor, showed us this before we could talk. The extraordinary rigmarole which I have had to use in writing about it is perhaps evidence that we take it as part of the natural order of things, which it is not. We have no colloquial word specifically for 'making a surface fit another by touching it at all points'. We very rarely need such a word. If we want things to fit in that particular way we give them flat surfaces and they do it automatically without our taking any further trouble. The boat builder cannot do this. He has a word. He speaks of making his curved surfaces 'fay' with each other. In some trades curved surfaces are said to 'mate' with each other.

Now the human hand does not take kindly to making things straight and still less kindly to making them flat and square, in any wasting technique. However, by testing from time to time with a straight edge, try-square and winding sticks, it can be done. But the labour of doing it, freehand, is really not very much less than the labour of making the first component any shape but flat and then fitting the second to it. The one serious disadvantage in that procedure as compared with free-hand flattening is that the second component must be 'offered up' to the first from time to time in order to see whether it is getting near the right shape. In masonry this offering up was excessively laborious, and so the mason preferred to square his stones, and he did it virtually free-hand. The brickmaker did likewise, but for him it was easy, once he had made a flat surface on which to form all his bricks. The carpenter also squared his timbers, but he did not work freehand. He applied the principle of the jig, and gradually extended it.

The most familiar example of a jig is a ruler. A jig is an appliance for guiding a tool in a predetermined path, independently to a greater or less extent of the operator's skill. A joiner's plane is essentially a chisel fixed in a flat jig, so that it flattens a surface with the use of much less skill and trouble than the chisel alone would require. But even the separate chisel, having its face flat, partly jigs itself once the cut has been started; and so did the carpenter's side-axe and saw. A flat file partly jigs itself. Although it is not easy to file a metal surface flat it is easier than flattening it with a cold chisel, which is in effect one ridge of the file unjigged by the other ridges. It is interesting however that

'The carpenter's side-axe.'
The way in which the cut surface of the wood jigs the tool is clearly shown.
The Emperor Maximilian and carpenters, from the 'Weisskunig' by H. Burgkmair

*By permission of the Trustees of the British Museum*

no jigged tool is good enough to make a metal surface perfectly flat. That is achieved by freehand scraping.

Rotary motion of the tool or work piece acts as a jig. Any old bit of iron will bore a perfectly circular hole, and a remarkably crude lathe will produce a perfectly circular piece to fit the hole. Hence, although the cylinder is not at all a versatile shape compared with the rectangular prism, its use became widespread from the earliest times, partly no doubt for magical reasons but also, or soon, for its being economical to make and fit – economical of time rather than effort, for a primitive lathe is no joke to work.

In forming processes the form – for example an anvil – and in casting processes the mould, take the place of the jig as automatic aids to flattening.

Although cutting a surface flat in any material is not inherently an easy job, the invention of jigged and self-jigging tools at least facilitated

it; and for the sake of versatility, and thence of avoiding fitting and offering up, and thence of economy, it became a normal procedure in all constructing trades to square the components before putting them together.

Thus the first and most important stratagem adopted to cheapen construction was the squaring and turning of components in order to eliminate offering up and individual fitting. The flatness, straightness and squareness which more than any other characteristic distinguish man's constructions from the works of God, derive from economy. We see the mark of economy in every building of squared masonry however magnificent it may be. Only the few remnants of ancient polygonal masonry remind us that the pattern of stone work where each stone is individually fitted can be very different from the cheap squared pattern to which we are accustomed. Cheap need not be nasty. But it is apparent that for one reason or another the ancients felt stone joints to be a blemish, and did their best to reduce them to hair-lines.

Now the object of squaring is to avoid offering up and fitting. Only those parts of a component which touch others need be squared. The sides and under surface of a beam need not be squared for the sake of that economy, yet from the earliest times we see that this was done, exhibiting the tendency to standardisation which appears in all constructional design.

It is a great convenience to reduce raw material to more or less standard pieces and then to design your construction in terms of those standard pieces. Such are bricks, boards, planks, deals, baulks, rolled steel sections, pieces of cloth, ropes, bolts, steel sheets and plates. These are convenient to the designer because they save him the trouble of shaping each component individually. He need not proceed like a man building a dry-stone wall who has to select every next stone individually to fit an individual place. He proceeds as if his material could only be found in standard squared pieces and as if his construction had to be designed in terms of those pieces even if this means using more material than strictly necessary. Thus in the steel frame of a modern building some of the material is under-stressed. Beams seldom need to be of the same depth throughout their span; but because the engineer proceeds as if he were confined to parallel rolled steel 'I' sections, he makes the beams of the same depth all along, or most of them. Standardised pieces of material provide the designer with convenient limitations on shape from the start of his job, of the sort which are always welcome, and perhaps necessary, to designers.

Standardised pieces of material must essentially be versatile. A rolled steel angle bar may end up as a fence post, a frame of a boat, part of an agricultural machine, or of a pylon, or of a window. Thus standard pieces will, wherever possible, be squared or turned. Their squareness will show even after they have been adapted to an unsquared construction. Thus a ship's plates show a square profile even after being formed to the compound curve of the ship's side.

Standard pieces tend to be small. They are made as much for the convenience of their producers as of their users. The object of converting or processing a raw material is not only to improve its properties but also to make it manageable in handling.

Before we examine the influence on design of economy in the remaining techniques, in wasting, casting and forming, we must consider the nature of skill.

In cutting a slice of bread, the intended result, say, is a slice half an inch thick of perfectly even thickness. To achieve this result the knife must not only be moved with force enough to divide the bread but must also be constrained by the interplay of our muscles to move in a plane, and a plane which is exactly parallel with the cut surface of the bread. The achieving of that constraint is skill. Achieving the requisite force is not skill. If too little force is used there is no result. Beyond that, the amount of force does not of itself affect the quality of the result.

Now in a bread- or bacon-slicing machine the revolving knife is constrained not by skill but the shape and arrangement of certain components of the system. There is a slide which constrains it to move in a predetermined plane no matter how it is pushed: a built-in jig. The constraint is mechanical not skilled, constant not variable. The movement of our eyelids is, as it were, mechanically constrained. One cannot bat one's eyelids skilfully.

Any system for making things which requires skilled constraint (exercised by a man or a computer) we shall call a skilled system, while if the constraint is mechanical we shall speak of a shape-determining system or, for short a 'determining-system'.

The criterion by which a determining-system is distinguished from a skilled system is simply the constancy of the constraint. If the shape which the material takes in the result is predetermined, whether by a form or by a mould, or by jigs – components which govern the relative motion of a work-piece and a tool – then the system is a determining

system. But any system in which constraint is variable at will is a skilled
system. The distinction has nothing to do with the source from which
energy comes to work the system. An electrically driven dentist's drill
is entirely constrained by skill except in its rotation, and it is a 'hand
tool'. But any modern hand-driven drill, once it has started its hole in
a piece of wood or metal, is constrained mechanically. You cannot
change its direction after that. You have become involved in a deter-
mining-system to which you are merely supplying energy. You are no
longer performing a hand operation, a skilled operation.

In determining-systems the change by which the intended result is
achieved is characteristically, though not invariably, continuous. In
skilled systems it is apt to be discontinuous; in other words the intend-
ed result is arrived at as a rule only by way of a series of intermediate
results. Thus if a piece of wire is being made by hand into a spiral
spring, it will be bent, then bent further, then moved, then bent again,
and so on; the constraint being altered at each stage. But if the wire

is wound onto a rotating cylindrical form, or mandrel, the straight wire changes into a spiral continuously and automatically, the constraint being constant.

A jig, then, or a form, or a mould, provide invariable constraints. Systems in which they occur are determining-systems, not skilled systems. But a system may of course be a complex of a determining and a skilled system. Thus a joiner's plane predetermines the thickness of the shaving but only in part predetermines the flatness of the cut.

The word skill, as I propose to use it, excludes any reference to 'know-how' and indicates simply a particular application of dexterity. 'There is not among us any that can skill to hew timber like unto the Sidonians'. The old usage of the word did refer to know-how, and certainly the modern usage does. I think however that it is necessary to differentiate between skill as the exercising of constraint on movement and 'skill' as know-how, for know-how, in making, is design. Thus according to the terms of this book one should say that anybody has skill enough to build a good dry-stone wall but that few know how to design one. In that work the so-called 'skill' is in deciding what shapes and attitudes will be allowable in the stone destined for some particular position, not in recognising a stone which has the shape already in the mind's eye nor in putting it in the envisaged attitude. Any

Skilled constraint exercised by a man or a computer'
Milling machine under 'numerical control'. A light shows the path of the cutter. It is not guided by a jig (i.e. a determining system) and the operator does not guide it either

*By courtesy, I.B.M.*

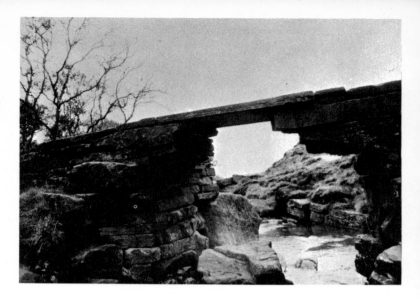

Packhorse bridge in Yorkshire
*British Railways*

one could do those things. It is making the decisions which is difficult, not the execution of them, whereas in sharpening a gouge, say, anyone can make the correct decision but few can execute it. Similarly the tree-feller's 'skill' is more in designing the shape of the cuts than in making them. He has to design his notch so that in the result the tree lies exactly where he intends after gravitation has done its work, and it is not easy to do.

There is now a widespread aversion from skill. In making we try, if we can, to eliminate skill by using know-how and determining systems. In music and sport we prefer that few should have skill while many listen or watch. In the fine arts we have lately tried to make execution as accidental as possible or, if not that, at least to give the impression of ineptitude. To say that a painter is craftsmanlike is (perhaps, was) an insult. Typing may or may not be more difficult than writing clearly but obviously it is not as skilled. The word 'foolproof' in an advertisement is taken as an inducement. By using one word for skill and know-how we effectively conceal this aversion from ourselves.

A system with skilled constraint, no matter what the source of power, usually gets the intended result rather slowly, partly because the change is apt to be discontinuous and partly because it is easier to maintain

the constraint if the energy is put in slowly than if the system is worked at full power. In hand work, power and constraint are apt to be inversely proportional as we all can see when we try to write too fast. In any wasting technique which requires skill one works the more gently as one gets nearer to the finished shape. With a determining-system no such caution is needed. It goes without saying that these systems will usually get their intended result more quickly than a skilled system can. That is why they were brought into use.

Prima facie it will always be cheaper to design for making with mechanical constraint than with skilled constraint because the working time will be less (numerical-control excepted). But the shape-determining systems which give mechanical constraint are themselves expensive and are apt to deteriorate more quickly than a man and his hand tools. Hence the cost of the determining-systems must be spread over many products if they are to be cheaper than the similar products of a skilled system. Since determining-systems predetermine shape the many products will all be identical. There will be quantity production of a standardised product.

Continuous production in large quantities, usually called mass-production, does not of itself imply any restriction on the shape of the product. By resorting to a suitable combination of techniques a determining-system for almost any shape can nowadays be devised. Any shape that skill can make could almost certainly be made by determining-systems. But whether it could be made by them economically is quite another matter. If the market for a product is very large and steady then the quantity produced can be very large, so that the cost of the determining systems is very thinly spread, and they can be exceedingly expensive without seriously affecting the cost of the product. But there is a limit, for the determining systems wear out and have to be replaced after a certain time. Their cost can only be spread over the number of products made in that time.

Skill will be wanted in making almost anything which, like a special determining-system, is made singly and not in quantity. But to make any product cheaply in quantity some determining-systems are required. Thus we revert in a large measure to the problem of making things cheaply one at a time or in small numbers. It is the effect of economy on that kind of making which we have to consider.

Our insistence on economy exercises its influence in the same ways on all kinds of making. Whether in mass-production or in hand workmanship, if economy is an influence, then the ways in which it can act

are in principle the same. The same courses of action can be taken to economise technique in all kinds of making alike.

One course is to use a material which is easily got and easily processed, and therefore cheap.

Another course is to keep down the amount of energy required to do the job by choosing, where other considerations allow, a material which is easily worked. In modern woodworking softwoods are seldom much quicker to machine than hardwoods. In hand working the difference is very noticeable and softwood is distinctly quicker and therefore cheaper for a man to work. But softwood is weaker and therefore its sections may have to be designed larger. Thus economy, by preferring a weaker material, affects the shape of what is designed.

Another course is, when designing for production by skill, to use as little skill as possible. Thus in cheap hand-joinery the fronts of the drawers in a dresser would be connected to the drawer sides by what is called a rabbetted and nailed joint, looking very different from the better dovetailed joint.

Another course, and one invariably taken, is to employ any standard determining-systems which you have already; for instance in joinery, a plane or an electrically driven planing machine, a hand saw or an electrically driven circular saw. The trade of joinery, indeed, is wholly based on the use of tools which are standard determining systems for making flat surfaces. Thus in joinery and many other constructing trades flat surfaces and square sections are used in season and out, sometimes where they are needed to make construction easier but nearly as often where they are not.

Half the flat surfaces which one sees in a room are in fact motifs, features of design chosen from among equally useful alternatives; though such is the pervasion of economy that probably no one has been aware that alternatives were feasible. There is nothing natural or inevitable about making the faces of a door flat. Ghiberti's doors in Florence are not so. But flat ones are cheaper.

The old-style chairmaker using skill and spokeshaves, found a curving and tapering chair-arm nearly as easy and cheap to make and finish as a parallel and straight one. The modern chairmaker using a few standard machines does not.

Another course to take if one wants economy in production, whether of one thing or of a quantity, is to design for an intended result which can be got by one continuous change rather than a series of intermediate results; or if this is impossible, then to design for the

'Fairly complicated'
Columbian press 1818

smallest possible number of intermediate results, the smallest number of operations. In practice this nearly always limits shape because, although the five kinds of technique are capable of making almost any conceivable shape, they can often do so only by making up for each other's deficiencies. A fairly complicated shape like the body of a small carburettor could be made by carving it out of a solid block of steel or brass using such wasting techniques as boring and milling. A long series of operations would be involved. The same sequence of intermediate results could be achieved, by means of automation, without skill being required, and so the job could be done quickly. But it would be quicker still to make it by diecasting, for this could be done at a single operation. Now this would impose certain limitations on shape. The thing, having been cast in the dies, has to be removed from them, and consequently parts of it must be slightly tapered so that once shifted it will draw out easily. If it seems important to get rid of the tapers then the deficiencies of diecasting must be made up by a wasting technique to cut them away. But this will not be done. The carburettor will be designed so that the tapers do not matter. The limitation will be accepted. But it will perhaps not be possible to cast certain holes accurately enough, and there the deficiency will be made up by reaming, a wasting technique.

Moreover the choice of diecasting will still, for the sake of economy, have indirect effects on shape. Zinc alloy will be preferred to brass, which would shorten the life of the dies by causing unwanted changes in them. The response with zinc alloy is better in that way, but as zinc alloy is not so strong as brass the body may have to be made thicker here and there than a brass one would.

It is through the insistence on reducing the number of operations perhaps more than anything else that economy in first cost influences the shape of things designed. Where there is no mass-production the tendency will be to design a product or a tool or form to make it, which can be manufactured by one technique unaided. If the technique is a wasting technique then the smallest possible number of cuts will be made and they will be made with standard jigged tools, therefore flat or turned cuts.

One further influence exerted by economy must be noticed. It will always be quicker to make a drawing and to work from a drawing which is made up geometrically, out of straight lines and arcs of circles, for drawing instruments are components of determining systems. There is little doubt that this encourages design in terms of those elements

and the tendency is of course strongly supported by the fact that standard determining systems for making squared and turned shapes are so widely available. But in some cases ease of communication as much as anything has prompted the use of, say, a profile made up of arcs of circles rather than a similar but free curve.

In its early days the Modern Movement was in part a reaction against the Victorians' profuse mechanical reproduction of ornamental forms which had originally been developed by freehand skill. The products of industry were held to be cluttered with such ornaments. It was held that machine tools and mechanical processes, i.e. determining-systems, ought not to be used to reproduce forms which originated in hand work, but that *The Machine* should be used so as to evolve its own characteristic forms.

The Machine was much revered. The thing was, to 'exploit to the full the capabilities of The Machine'. That was essential to salvation. The Machine was held to be capable of giving us everything good, at a very cheap price. It was taken for granted that machine tools were manifestations of The Machine. Any machine tools, then, were capable of making things which were good and also cheap.

So they are. But they are much more easily capable of making things which are bad; and hand tools are, if anything, capable of making things which are worse.

Tools are merely components of systems. They are made by men and controlled by men according to their evil or less evil minds. Tools of themselves make nothing, have no capabilities, and produce no forms. (Neither indeed does The Machine, which after all does not exist and so has not much opportunity.) If a man is limited or influenced by the capabilities of a machine it is because he has chosen that machine, and not chosen to buy, or design, or have designed, a machine with different capabilities. If he chooses to limit himself to the forms which certain machines are capable of, he may. If I choose to limit myself to the forms which a handsaw, a hammer and a bag of nails are capable of, I may. But I am not entitled to say that those forms are the characteristic forms of The Hand Tool; they are characteristic of The Bad Workman.

Mass-production is capable of making things both cheap and of very good quality, but mass-production does not essentially depend on machine tools or any other sort of tool. It depends upon the size of the market for your product and on how much you can afford to spend on organising manufacture.

The primary concern of all manufacturers is not with making things but with getting rid of them afterwards. If you know that you can expect to get rid of large numbers of the same thing year in and year out, or at any rate for a good long time, then it may be safe to raise and spend the money needed to arrange for the thing not only to be mass-produced, but mass-produced automatically. Hitherto complete and thorough-paced automation has not been possible largely because of difficulties of controlling operations automatically. Electronics are now making it possible. The ideal before what I have loosely called mass-production is that the form and quality of the product shall be predetermined in every detail before one single thing has yet been made. The ideal is that once production has started the factory staff shall be able to lock the doors and go happily away. To arrange for any approach to automatic production, with the form and quality of the product even moderately predetermined (instead of their being partly determined during production by the skill of the makers) costs a great deal; but to predetermine a good form and quality rather than a bad need not increase the cost disproportionately, and sometimes hardly at all. In general, mass-production allows the designer more freedom of choice than intermediate or hybrid methods.

The means employed to sustain the market required by mass-production are rather beyond the scope of this book, but this may be said of them. No one understands the cause of war as a morbid condition of social behaviour, but everyone knows the symptoms. A principal one is the diligent production of things – munitions – which are soon afterwards destroyed. A detached observer might suppose that our purpose in this was to run down the resources of society instead of building them up. He might suppose that we have the same purpose when we make things of such a quality that they wear out quickly and have to be made all over again (so as to sustain the market) or when we build 'permanent' houses to last only sixty years (with of course a nice sinking fund to replace them; and where are the sinking funds of post-1918 Germany, say?).

Making things in order to have something to destroy might seem to this observer from Mars the characteristic behaviour of our society. He would also note that any individual who behaved like this, would be treated by society as mad.

If you are designing for thorough mass-production there will not be much question of exploiting the capabilities of machines. If the machines you already have will not do what you want, you will scrap

them and design some new ones to do it ('you' being of course a whole orchestra of designers). If you are designing for some sort of hybrid production – and most production is still that – then the question arises, 'capabilities of what machine?' The answer may well be, 'of the machine that we have got, and of Tom who sets it up and George who works it; and they could make it do anything you like except talk, if you gave them half a chance. But don't you start them doing anything fancy with it because that is going to cost too much!' In hybrid production it is always cheaper *not* to exploit to the full the capabilities of a machine, and usually cheaper still to use the wrong machine.

The influences which are exerted on the shape of designed things by the techniques we use to make them may be summarised as follows:

1  The techniques which change the size and shape of pieces, wasting, forming, casting and constructing, exert if taken together no influence or a negligible influence on the shape of what we design. They could only do so if they were incapable of making certain shapes. But taken together they are capable by now of making almost any desired shape in almost any material – at a price!

2  The processing techniques which change the properties of materials are rarely capable of altering those properties either locally or independently of each other. Thus deficiency of technique restricts us to designing only what the combinations of properties as found will allow. The indirect influence on shape is very considerable.

3  When we attempt to keep down the cost of using techniques we may strongly influence the shape of what is designed. The principal measures taken to economise technique are:

*a*  To use the cheapest source of energy available.

*b*  To use the cheapest material where alternatives are available.

*c*  To use an easily worked material so as to economise the input of energy.

*d*  To use as little material as possible.

*e*  If the market will absorb quantities of a standard product, then produce in quantity, so that production may be made automatic and independent of skill by the use of special determining-systems, jigs, forms, dies, press-tools, moulds, etc., whose high cost can be dispersed by spreading it over the large number of products.

To design for a shape:

*f*  Attainable with as little skill as possible.

*g*  Attainable in few operations, and if possible only one.

*h* Attainable with standard squaring and turning operations; i.e. by using any standard determining-systems which are available such as jigged hand tools, or machine tools, which invariably incorporate components acting as jigs.

*i* Attainable by constructing with standardised constructive pieces if possible.

*j* (Not of great importance as a rule.) Which is easily drawn.

All these except *e* apply as much to making things singly as to making them in large quantities.

The poet invents new juxtapositions of words and phrases which convey new thoughts. The inventor makes new juxtapositions of things which give new results. Neither the poet's words nor the inventor's things have any remarkable properties of their own. They are everyday words and things. It is the juxtaposition of them which is new.

Before anything is made a desirable result is likely to have been envisaged. The man who envisages the result may already know of a system or several systems which are capable of giving rise to it, and in that case no further invention is needed. If you say, 'Invent me something which will result in these books and this alarm clock remaining at rest at this level which I indicate on the wall', I shall at once think of a shelf on brackets, which I remember to have seen giving the same sort of result with the same sort of things before. I shall not be hailed as a great inventor. I have simply had to determine the class to which the specified result belongs and to consider which devices of all those in my memory give rise to results of the same class. But have I really done even that? I doubt it. I have simply envisaged the books up there on the wall, compared the vision with various sights stored in my memory, found one which showed books half way up a wall, noticed that there was a shelf under the books, and concluded that a bookshelf would do now because it was suitable before.

That can be a bad procedure. There may be other systems which are better than the first which turns up in the memory.

The author once set about designing a draining rack. It was for the plates, pot-lids and so forth used by his family while living in a tent. It had therefore to be very small and very light. Because he started by thinking 'I must design a draining rack' instead of considering what kind of result was wanted, his train of thought was conditioned unprofitably. Racks act by supporting. Any instance of a rack which will support plates must have dimensions conformable with those of the plates, and there is a limit below which its size and therefore its weight cannot be reduced.

After prolonged thought the designer realised his mistake and started to consider what result he wanted, namely, a row of plastic plates

edge-on in mid air. He then started to search his memory for results of the same class but not necessarily involving similar objects or, at any rate, objects which were closely similar. Doing this is not as easy as it sounds. Because it was not easy his mind ran to a result involving objects which, if not closely similar, at any rate were suggested by a very obvious association, namely a row of cups hanging on hooks. The unconscious association must have been plates – saucers: saucers – cups. Thus the thought of plates unearthed the memory of cups.

It was then easy to arrive at the required invention, a thin stick carrying a row of thin wire hooks like cup-hooks; for the desired result was by now well in mind, and the objects in it too, the flexible rather soft plastic plates, which being rather soft at once suggested that holes might be cut in their rims.*

Designers and their clients seldom formulate their purposes in terms of the desired results, but on the contrary habitually do so in terms of the systems of things which give rise to them. As the example of the dish rack showed, this may be a bad habit; but it will only be bad if some new factor in the situation, such as plates made out of easily drilled plastic, is overlooked. Otherwise the designer's normal habit is mere common sense. If you want to enable someone to sit, it will be idiotic to proceed in the way that students of design are sometimes advised to do, and think out the whole problem from first principles, as though all the people who for the last four thousand years have been making and using chairs were half-wits. Where the problem is old, the old solutions will nearly always be best (unless a new technique has been introduced) because it is inconceivable that all the designers of ten or twenty generations will have been fools.

When a desirable result is envisaged and the memory, being searched, shows no immediate picture like the bookshelf, then the same procedure must be followed as was done with the dish rack. A similar result involving different objects must be sought, in the hope that the device which gave rise to it can be adapted to the objects which are now intended, or that these can be adapted to the device. It is here that our habit of refusing even to name results, and our habit of referring to them by way of mythical actions, and all the habits of mind associated with them and with the idea of 'function' (Chapter 11), all these help to make our task more difficult and to inhibit us from discerning analogies between different results; for we are averse from thinking of classes of results, as such, in any case, and have no proper tools to do the thinking with. Invention can only be done deliberately if the

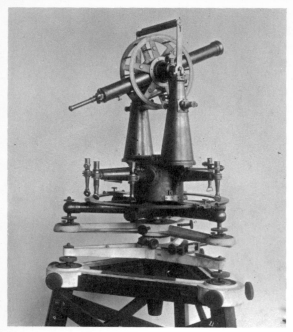

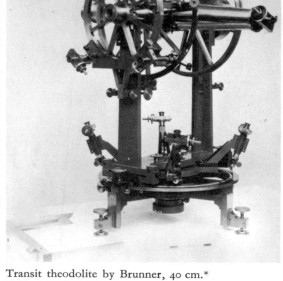

Transit theodolite by Troughton
and Simms. 2′0″

Transit theodolite by Brunner, 40 cm.*

Microptic theodolite No. 2 by Hilger and Watts Ltd., London
*By courtesy of Hilger and Watts Ltd*

The fine workmanship of all three theodolites should be noticed

'The visible schema of a device is the essential principle of arrangement', as these five photographs show

*Right:*
Nasmyth's original steam-hammer, (model) 1840
*Crown copyright, Science Museum, London*

*Left:*
Nasmyth's inverted steam-engine, (model) c. 1848
*Crown copyright, Science Museum, London*

inventor can discern similarities between the particular result which he is envisaging and some other actual result which he has seen and stored in his memory (which must of course be well stored so as to give him a wide choice and therefore a better chance). The fact that we habitually visualise particular results is something of a stumbling block too, in its way. We *envisage* or feel the desired result. We see it or feel it, objects and all. Our memories are visual or muscular memories of particular results, not conceptual memories of classes of results. We see or feel in our memories particular results each including a particular system with its particular components and above all with the particular objects which were involved. Out of that lot we have to abstract the class of result, averting our attention from the particular system and objects. This is not easy when one is reviewing the bloodless ghosts of memory.

If an exact classification of devices were made according to a close analysis of the characteristics of their results it would presumably be possible for computers to invent, provided that their memories were full-fed. For all I know they are doing it now. But it may be doubted whether the classification could be subtle enough or the feeding full enough to enable them to spot far-fetched similarities with the same genius which human inventors have sometimes shown. What association gave Watt his centrifugal governor? A merry-go-round? Who is going to feed a computer with merry-go-rounds?

An inventor's power to invent depends on his ability to see analogies between results and, secondarily, on his ability to see them between devices – a thing which is very much easier to do, for the visible schema of a device is the essential principle of arrangement; and we are fairly well habituated to recognising similarities between devices by means of that. It is indeed our normal means of doing so. An example of analogising was quoted in connection with the design of the lever (page 43). When the designer had his brain-storm he saw an analogy with the yuloh which was the antecedent of his doubled lever. He was looking for a combination of results – the fulcrum steadied, the stone abutted to a block on the lever, the lever stiffened at the fulcrum. The association by which the antecedent was fetched up from the memory was partly visual; the yuloh has a step in it, and a lever with a step in it suited the second result of the three desired. But the association was partly by feel, I believe. I had imagined the feel of the lever working, and had once done the same for the yuloh.

It is unfortunately impossible now to discover what trains of thought

did in fact lead to the invention of most of our devices, but it is easy to construct hypothetical trains of thought showing the analogies by which they might have been arrived at. For example, we may suppose that a clasp knife was invented in a desire to make a knife short enough to put in one's pocket. A sheath knife was too long. 'How', the inventor asked himself, 'can it be made shorter? How do you make things shorter? What results are shortened results? A telescoped result and a folded result come to mind: Like my footrule.' Here he has found a fruitful analogy, for he envisages a knife folded, handle to blade, like a foot-rule; and the picture in his mind's eye shows him the edge of the blade guarded by the handle – an extra advantage thrown in for nothing. The invention has been made. It remains to improve it by adding a system to keep the knife shut or open.

Such an example may suggest how the process of deliberate invention works. But there is something between deliberate and accidental invention. This takes place when the purpose, the desired result, is inchoate or unconscious. We may suppose that the inventor of the typewriter watched a pianist playing very quickly and thought 'How quickly the notes follow one another. I can scarcely distinguish them. C – B flat – A, could it have been? Letters. If only one could write so fast. Each key writes a letter as you press it. Press. Printing press. Press the key and the little oblong hammer hits the string. Presses the string down. Presses the letter. The letter is printed on the paper.' There he has the typewriter, each hammer in the action of the piano printing its own letter. He saw the analogy between the two results, a sounded letter and a printed letter.*

* Some slight colour is given to this story by the fact that early typewriters had piano keys

A desired result is not always envisaged before an invention is made. More commonly perhaps an accident will produce a result which is only then seen to be desirable. Whatever a designer's purpose may be, he ought always to watch for accidental variations of things designed and take advantage of them in the way of appearance or use, if their results suggest anything to him. Many, if not all, scientific discoveries are made by a kind of inspiration fastening on an accident.

The authors of most of the inventions based on accidents are forgotten. There can be little doubt that most of the cardinal inventions were made thus, before history; but there have been recent examples. A circular saw can be used to cut a groove in wood, the groove being as wide as the saw is thick (or a little over, the teeth being set). The saw fits the groove. Some sawyer or millwright made a mistake when he fixed his saw on its spindle. The spindle ought to have been at right angles

to the face of the saw, but it was not quite at right angles. He noticed that the groove it cut was slightly over size. This must often have happened. But someone instead of correcting the error was inspired to increase it so that the saw visibly wobbled – in which condition it is called a wobble saw or drunk-saw – and by this means he made a thin saw cut wide grooves. The width of the groove cut by a drunk-saw is twice the amplitude of the wobble, and it is a most unlikely looking tool, but an effective one.

To take advantage of such a chance occurrence is a considerable creative feat. These things always seem so obvious after the event. An inventor who does this is able to do it because he is able to see not only the particular (and annoying) result under his nose but also the whole class of results which it typifies; and further, because he can envisage the other results of that class in all sorts of different chains of results. He is obviously more likely to make the invention, the discovery, if he has already envisaged such a class of results and desired it before the accident occurs. His mind will then be prepared.

As we have already remarked, there is no essential difference between invention and scientific discovery, for both are the disclosing of a fact about the natural behaviour of things or of combinations of things. Pasteur speaking of scientific discovery said that 'Chance favours the prepared mind.'* A classic instance of this was seen in Fleming's discovery of penicillin. He did not discover penicillin. The action of moulds on bacteria had been observed and reported before he also chanced to observe it. But he had a prepared mind in that he had already envisaged an antiseptic which would be carried in the blood stream, a desirable result never yet attained and one which, to judge from his profession's lack of interest, was very unlikely to be attained. But he believed in its possibility and thought that in the result of penicillin's action on bacteria he perhaps saw a means to that end – as in fact he did. The remarkable part of his achievement was his vision of the end result and persistent search for it. There can be little doubt that most apparently impossible results have been envisaged only after a chance discovery has strongly suggested them and not, as with Fleming, before some apparently trivial accident has led a man of vision to them.

The two commonest sources of chance discovery or invention are play and error. In play one may fiddle about with things aimlessly – or without conscious aim – and suddenly discover an unexpected result, much as one solved the wire puzzles in Christmas crackers by

* Quoted by W. I. B. Beveridge in *The art of Scientific Investigation*

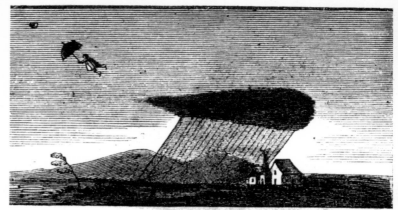

*From Struwwelpeter*

fiddling with them. We shall never know how many of the primary inventions are due to children's play.

In finding by error one may put together a known system in the wrong way, as with the drunk-saw, or make components of the wrong shape through inadequate technique and find that the system gives rise to an unexpected result of which advantage can be taken. If you are bad at building skin boats you may make one unusually box-like and find it unusually stable. You may make another one unusually fine and pointed, and find it unusually fast. And so on.

The man with a vision of some desirable result may deliberately court chance occurrences by experimenting with one thing after another almost at random, as Ehrlich did before he discovered Salvarsan, and Goodyear before he at last discovered how to vulcanise rubber.

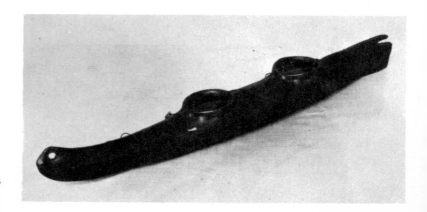

'You may make another unusually fine'. Eskimo 'Bidarka' from Alaska

*Crown copyright, Science Museum, London*

We see, then, that findings always precede design. The finding process may be extremely simple. There is nothing in finding the appropriate system for supporting books against a wall, or for protecting feet. The finding becomes inventive when analogising is involved or that vision which prompts us to take advantage of accidental occurrences. Design as distinct from invention is prescribing a particular instance of the system which has been found, in order to accommodate given objects and a given prime mover; or the combining with this of palliative and other devices. But they also have to be found and their finding may be inventive. Deliberate invention as distinct from design is the finding of a system or a complex of them which will give rise to a desired result, the system or something analogous to it being previously known to the inventor but not previously associated with the particular objects in the desired result (as for example in the case of the dish-rack quoted above).

I do not know that in the field of inventing devices anything comparable with the heroic methods of Ehrlich and Goodyear has ever been applied. It may conceivably have been done during the search for perpetual motion. But it is certainly very near the truth to say, that if you cannot find any analogy at all with your desired result, then you cannot invent deliberately. If you desire the result of a sky-hook or any other for which no system is known and no analogy can be found, then you can only prepare your mind and wait for something to turn up. And after all, nearly every device we have has grown out of primary discoveries which simply turned up. One might even differentiate invention and discovery by confining the term 'discovery' to inventions arising from chance occurrences not deliberately courted.

There seems no reason, on first consideration, why a system of forces should not first be invented by reasoning from known principles of mechanics, and then clothed in things. But this does not happen. Why should it not? Let us try it. Of all desirable inventions a sky-hook is the most desirable. It would simplify technology quite noticeably. Let us first invent a complete system of forces for a sky-hook and then clothe it in things, and make our fortunes. The problem is to invent it, not design it. A helicopter is a sky-hook of a sort, but somewhat unhandy in the home. We are to invent a sky-hook. The question arises, 'What exactly do we mean by a sky-hook system?' Well, what do we mean? When we know what *things* we mean by a sky-hook system, then, and not before, we shall be in a position to describe the system of forces. Invention must come first.

You cannot proceed by saying, 'Here is the result, thing suspended in mid-air; let us think out how to produce it', unless you make some assumption about what it is suspended from or propped up by. If your assumption proves good, you have made an invention. If you already know that it is practicable you are using an invention which has already been made.

If there had been no inventions there would be no theory of mechanics. Invention came first.

Theory is an aid to variation of inventions, that is to say, to design. A designer who understands the essential principle or arrangement and the response will be able to reason about his trial variations. This one has the right arrangement but the desired change is not taking place; why? That one has the wrong arrangement, therefore the desired change can never take place and it must be abandoned. But theory is not an aid to invention as such, except in so far as it enriches an inventor's feel for his job, and no one knows how far that can be. Indeed no one knows whether after all a knowledge of theory actually inhibits an inventor's creativity. In time we shall find out. Our entire theoretical knowledge has been founded on abstractions taken from the fruits of inventions made without theory. Whether theory is a vivifying essence which will enliven our inventive faculties, remains to be seen. It is becoming a commonplace that scientific discovery is an art not a science, being a matter of chance favouring the prepared mind; but we do not yet know whether the mind is prepared or stultified by loading the memory with theory. Presumably some minds will be helped by it and some not. We may be improving our powers of design at the expense of our powers of invention. Moreover it is arguable that we have inventions enough already.

Anyone with experience of training designers will confirm that a man who is capable of invention as an artist is commonly capable also of useful invention. Leonardo's exceptional genius in both useful and artistic invention seems to have fostered the idea that he was exceptional also in combining these two talents; but this is not so. The combination is usual rather than exceptional, so usual in fact that one is led to suspect that both are really different expressions of one potentiality.

Making waves'. Motor Torpedo Boats

*Ford Jenkins, Lowestoft*

Chapter 7    We can wish for impossibilities
             Utility. Improvement. Economy

We can wish for impossibilities. We can wish and imagine ourselves floating in mid-air because we do not experience floating as necessarily accompanied by certain other conditions such as displacement of an equal weight of fluid, but as an event by itself. We are able to imagine any event without its necessarily concomitant events, the other parts of the response. We can imagine a ship steaming at thirty knots along a canal without making any waves because we do not see making way through the water and making waves as inseparable parts of the same manifestation of energy but, as 'cause' and 'effect', separate.

We get experience by attending and we do that in effect by abstracting one thing or event from all those in reach of our perception and then ignoring the rest. Thus it comes naturally to us to envisage events in isolation. And of course it comes naturally enough to us to envisage

the events we want and to ignore the ones we do not, so that we can wish for a sky-hook and imagine hooking a hook onto thin air without also imagining the necessary concomitant of that event, the hook falling.

When we wish for something impossible we nearly always wish for a possible event, for example hooking onto air, with impossible concomitants, for example not falling down. But not falling down is a perfectly possible event in itself, as a response to a different system, such as a shelf and brackets. We never wish for or imagine impossible events or things. We cannot. We can only frame our wishes in terms of past experience, in other words of the possible.

The trouble with a sky-hook, or a magic carpet, or a perpetual motion machine, is that they involve unknown forms of energy; that is to say, magic. There may possibly be forms of energy yet to be discovered, but it seems fairly probable that the forms required for those devices will not turn up.

Because we can wish for impossibilities we do so, and we also secretly hope that our wishes will come true. It is not easy for us to accept the fact of Nature's truck. The poet may say 'Ne'er the rose without the thorn' but we are going to breed a thornless rose. We are going to get something for nothing! The curse of Adam does not apply to us; we have swapped it for one or two new ones. We have raised our standard of living.

All cynicism apart, it is obviously questionable whether a higher standard of living entails more happiness, but it is not questionable that a higher standard of living gives better opportunities for avoiding unhappiness. Utility has a strangely negative character. We speak of the secret of happiness, for its causes are elusive; but there is no secret about the causes of unhappiness: thirst, hunger, want of sleep, exhaustion, pain, and too great heat and cold, are evils which can effectively prevent happiness. Utility has a negative character, because useful devices are adopted in the main for the sake ultimately of avoiding such evils.

From the fact that deadly injury, pain and exhaustion prevent the fulfilment of the universal wish for happiness, men have always tended to infer that if only life were safe, comfortable and effortless they would be happy. It does not follow. And moreover the essential actions for avoiding evils cannot all be achieved safely, comfortably, and effortlessly. But evidently this inference has largely determined our modern wishes and hence the devices which have been born of them.

The purposes behind our now insensate search for more and more economy by the improvement of devices originated in these two fallacies: that because the parts of a response are seen as separate events they can be separated, and that because hard labour can prevent happiness, the more ease we have the more happiness we shall get. The first of these two is as old as magic and fairy tales, while the other must be older. But to see magic coming true is something new. To all appearances we really have separated the parts of the response, and we have indeed banished hard labour from many lives. And yet we are not quite happy. Happiness is just round the corner, and we shall reach it when we have improved everything a bit more, just a bit more.

Our insatiability is of course carefully tended by the salesmen. They do not want satisfied customers. They want customers who are always expecting some new 'improvement'; and that means something which provides economy on both its levels, cheaper in price when bought and exacting a lower cost in labour time and trouble when in use. For us no device ever works properly, for we can imagine impossibilities and improbable possibilities as well, such as electric light. Insatiability has its advantages now and then.

The process of improving a device is mainly a process of accretion. What may be called palliating or economising devices are added to or incorporated in the original device to such an extent that the simple foundation of the resulting complex is often difficult to discover.

All that remains after a typewriter has been used – after energy has been put in and has passed through the system – is marked paper. That is the result of the typewriter, and the only parts essential to it are the type-bar ends, the paper, the ribbon and the roller. With those and some laborious care you could type a letter. The rest of the machine is an accretion of subsidiary palliative devices – keys, carriage and all the rest – which give economy, i.e., eliminate labour and care and give speed. Similarly, once you have stretched the warp you can weave with an ordinary needle. The loom is palliative.

Unpalliated devices are caviare to the general. When Orville Wright made the first powered flight in 1903 anyone of sense would have much preferred a bicycle as a means of getting somewhere. Yet the Wright's aircraft satisfied the requirements of use.

'Utility' might be represented by some such analysis as:

The satisfying of the requirements of use. . . . . . . . 10 parts
The satifying of the requirements of economy . . . . . . 90 parts

Palliation directed to the kind of economy we call convenience has

gone mad. But this by no means implies that the majority of palliating devices are trivial misuses of ingenuity. Without lubricating and other anti-friction systems, for example, the wear and loss of efficiency in machines would be so huge as to make them quite useless for lack of economy although, like the Wright's first aircraft, just capable of achieving the intended result and therefore demonstrably satisfying the three requirements of use. Utility is not a matter of effectiveness but of acceptable effectiveness.

Adopting an invention, whether it be a new way to a familiar result or to a result never previously realised, is a decisive step. When once it has been taken it remains to be seen whether a good bargain has been made and whether the bargain can be improved by palliative accretions to the invention which reduce the cost of it.

It often happens that one invention supersedes and outlives another not because it achieves any different result but because it is capable of carrying a greater variety of palliative systems, or some particularly desirable palliative system. Thus the ship superseded the raft, which is wet and top-heavy if carrying much freight, and the aircraft superseded the airship, which is slower. Yet the raft is much harder to sink than the ship, and the airship is less liable to fall down than the aircraft.

From these considerations it follows that what we see of a device is rarely the essential part, the *sine qua non*, but nearly always merely the superstructure which economy has imposed on it. Economy, if sufficiently insisted on, can exert a very powerful influence indeed upon the appearance of devices though, since requirements for economy are invariably conflicting, even economy never does in fact govern appearance, as we shall see in the next chapter.

The requirements for design conflict and cannot be reconciled. All designs for devices are in some degree failures, either because they flout one or another of the requirements or because they are compromises, and compromise implies a degree of failure.

Failure is inherent in all useful design not only because all requirements of economy derive from insatiable wishes, but more immediately because certain quite specific conflicts are inevitable once requirements for economy are admitted; and conflicts even among the requirements of use are not unknown.

It follows that all designs for use are arbitrary. The designer or his client has to choose in what degree and where there shall be failure. Thus the shape of all designed things is the product of arbitrary choice. If you vary the terms of your compromise – say, more speed, more heat, less safety, more discomfort, lower first cost – then you vary the shape of the thing designed. It is quite impossible for any design to be 'the logical outcome of the requirements' simply because, the requirements being in conflict, their logical outcome is an impossibility. It must however be remembered that by the use of magic, that is to say by unknown forms of energy (of which electrical energy was recently one) impossibilities can be designed; but now that we have nuclear fission and fusion we may have come to the end of magic.

Of the many inevitable conflicts between the requirements of economy the crudest is that between durability and low first cost. The design of consumer goods according to 'built-in obsolescence' is arbitrary indeed.* At other levels there are inevitable conflicts between, high speed and low maintenance, high speed and low first cost, high speed and low running cost; light weight (for say, low fuel consumption) and high strength (for durability and safety); more daylight (through large windows) and more quiet, with even temperature in sunny weather; more cargo capacity and more speed; a keener edge and a lasting edge; and as many more as you like. There is also a special group which arises because all requirements of economy demand, prima facie, a minimum condition of the device; but finding out what the minimum condition actually is will be most expensive so that it

* Vance Packard: op.cit.

'The qualities of workmanship, a good surface, a neat fit . . .' Esso refinery, Fawley

*An Esso photograph*

will always be cheaper merely to approximate it; but, again, if you approximate it you leave no factor of safety. You therefore, in practice, abandon it altogether. The factor of safety you apply is of course entirely arbitrary and varies according to the country you are practising in.

It will be noticed that most of these conflicts ultimately derive from the nature of a response with its inevitably concomitant, and in most cases unwanted, changes.

A few years ago one would have said that a conflict was inevitable between the requirements of economy, as low first cost, and the requirements of appearance; for those qualities of appearance which hitherto have been universally required are the qualities of workmanship: a

ravelling clock by Thomas
'ompion

ent to the Science Museum, London, by
Irs M. L. Gifford, London

good surface, a neat fit, a clean job and so on. These are the essential, though unacknowledged, bases of design; but they are largely useless and, unfortunately, avoidable. Probably few people realise how nastily things can be made and still work well enough. There is still so much good workmanship about that we take it for granted and turn up our noses at the people who take the trouble to produce it.

The requirement of accessibility is capable of giving rise to acute conflicts. One of the designer's most familiar predicaments is to be faced with several things all of which for one reason or another have simply got to be in the same place. The enormous elaboration of modern devices makes this inevitable. They are systems of systems of systems, and they have ancillary, accessory, subsidiary, and every other sort of system combined and compounded with them. In addition the requirement of accessibility is also capable of conflicting with those of economy, use and appearance.

A cargo ship provides a convenient example of conflicts between requirements for economy originating in the nature of a response. If you make a ship bigger it will carry more cargo and make more profit. But it will float deeper and have more surface in contact with the water. Therefore when the ship moves there will be more resistance and friction. Therefore more power will be needed; therefore the engines must be bigger and more fuel must be carried; therefore there will be less room for cargo than the extra size suggests. Moreover the greater power will cost more to produce. Moreover the ship being deeper draughted will be confined to loading and discharging in deep-water harbours. One can see that here there will be room for argument about what will be a profitable size of ship for any given time or place.

Some of the most delicate compromises are required in planning buildings, not only because the objects in the system, the spaces to be enclosed, may themselves be a matter of compromise, but because so often several of them demand the same position. If you want to combine with your enclosure some windows for admitting sunlight you must face the sun. If the site has a narrow frontage towards the sun, not all the rooms can face it. And suppose, as often happens, that the only drains to which you can connect are on the same side as the sun, then either the sinks and w.c.s, which have a poor claim to the sunlight, must be on that side, or you must spend a lot of money on the drains and spend less on something else of more obvious importance. Or again, on the first floor of a house whose size is limited by cost, if

you want separate access to each bedroom you may only be able to get it by way of a passage, so that the size of the bedrooms must be still further reduced to give room for it.

The conflicting requirements which arise in planning buildings can be far more involved than these. The whole art of planning is compromise. Always the requirements indicate unmistakably that several different parts of the building ought to be in the same place at once.

Conflicting requirements for access are artificially raised by designing 'for the market'. We find for example that a suitcase might always be a little bigger. Now if it is designed to be thicker than usual, one's arm cannot hang vertically when carrying it, and gets painfully tired. Therefore one or both the other dimensions must be increased. Clearly the vertical dimension must be less than the distance from hand to ground. Since you do not know how tall the user will be you design this dimension to suit what is statistically the most probable height of the users. The shorter users will now trip over the thing and the taller ones will wish that better advantage had been taken of their height. But even the size which suits the probable height will be too big to go conveniently onto the luggage rack of a train. But it will fit the boot of some cars. But it will not fit others. And so on.

Here is the familiar problem of the designer for production. Since he does not know who the user will be, he does not know what particular systems the thing will be a component of and therefore he cannot really design it at all. A similar conflict is found in the design of easy chairs. Within limits, the lower they are the more comfortable most people find them, at present. But the lower they are the more difficult do old people find it to get out of them, even to the point where they find it impossible. Here however the decision is all too easily made. Old people do not buy furniture, while young ones do. Therefore industry, which can only live where consumption is active, caters more for the young. It is hard luck to be old. But it is also hard luck to be unemployed.

Such conflicts as these originate in the requirements of economy which encourage production in quantity. The requirement for a low first cost may conflict with the requirements of use and of access, as may be seen in the case of a small table, which needs to be fairly cheap, fairly light and yet steady on its legs. The use of wood makes these things possible. Experience has shown that the method of constructing tables which gives the most steadiness for the least money and weight is what one finds in a kitchen table – four legs, four rails, and a top.

C 4½″

B

A 30″

25½″

Fig. 15

Fig. 15 shows the corner of it. It is no more an ideal solution than any other design, but it works pretty well and has become generally accepted as a standard type. Several million people have used such tables to eat at and write at in the last two hundred years and very few if any are known to have been much the worse for it. The dimensions shown are a compromise. It would be nicer if A were two or three inches bigger, so that you could cross your legs; and if B were two or three inches smaller so that the table top was nearer your lap. But C cannot be much less if the table is to be cheap and steady and durable, so you must put up with A being rather small and B being rather large.

Here science steps in, and after it hopeful thinking. Someone discovers that if dimension B is in fact reduced two or three inches, you can, given a rather low chair, adopt a posture when writing at the table which is better for your health than the posture you ordinarily use. Well and good. The assumption is then made that if you do use a chair and table of those heights you will actually adopt a better posture. Similar assumptions are that if people can afford a healthy diet they will adopt it; or that because they can avoid smoking, drinking and tight shoes, they will avoid them. People have not hitherto been observed to act like this. Human behaviour is as much a fact as human physiology, though not so conveniently measured and therefore more conveniently ignored. People *use* furniture. It does not use them. It does not make them assume postures. There is no reason to suppose that the behaviour of people will change because the height of tables changes, nor is there any reason to suppose that they will find a lower table comfortable. Some millions of people find a wooden pillow comfortable; some millions do not. Some millions of people like sitting on the floor and some millions like sitting on chairs.

It is quite true that reducing the height of a table three inches really matters very little as a rule; and we do not know whether most people actually will sit better at lower tables, because no large comparative experiment appears to have been made. But suppose that you prefer a table twenty-six or twenty-seven inches high, which after all is about the best reason for having one, then the rails must go; then the top must be thicker, or the table will be springy and vibrate when you use it; then the top must be of well selected wood or it will twist and the table will be standing unsteadily on three legs. Therefore the table must be heavier and more expensive, unless the top is built up and veneered, in which case it will be too easily spoilt. A good connection

between the legs and the top will not be simple either.

Here economy in technique conflicts with access. There is not the least difficulty in designing a table without rails, but it comes rather expensive if properly made. It always did. That is why tables are made with rails; not because no one had the sense, in two hundred years, to think of leaving them out; indeed there were many tables of the trestle type which did without them.

Designers have occasionally been urged to seek for 'ideal solutions of design problems' or words to the same effect. There can be no ideal solutions, as the preceding pages will perhaps have suggested. Design is not like that. There are, however, occasions when it is possible to determine temporarily what is the best practicable balance between opposing requirements of economy, such as high speed and low fuel consumption. The same kind of thing might be done in the design of a structure such as a viaduct across a stretch of bad ground. If there are many piers to support it there will be many rather expensive foundations. If there are few piers there will be fewer foundations but each will be more expensive because each will carry a greater load; and moreover the spans of the viaduct being longer will be more expensive to erect. But again, one long span may be cheaper in itself than two short ones, or it may not. If the engineer really knew what he would find when he dug the holes for the foundations, and if he really knew what would have happened to wages and the price of steel and concrete by the time the viaduct was building, he would be able to state a true problem here and find out the most economical solution mathematically. But his client would still want something cheaper.

* Can now, indeed (1967).

It is said that by the aid of computers we shall soon* be able to arrive at the correct solution in such cases with certainty. They are clever, these computers! They are going to show us the cheapest answer. But if they think their clients are going to be satisfied with that, they are not so clever as they think.

There is a difference between useless and ineffectual, no matter what the dictionary says. All the things which can give ordinary life a turn for the better are useless: affection, laughter, flowers, song, seas, mountains, play, poetry, art, and all. But they are not valueless and not ineffectual either.

'Design', to many who practise it, must mean, simply and solely, useless work. Nothing they do is concerned with the requirements of use, economy, and access. Such are graphic designers, designers of printed textiles, of decoration on pottery, wallpapers and similar things. To engineers, designers for industries, architects, and naval architects, 'design' means something quite different; yet in all the things they design useless work is invariably done and sometimes a great deal of it.

There is nothing strange in this. Men and animals too perform an immense number of actions every day which are useless, and we find throughout life the same tendency which we find in design and making. In useful design and making there has from the first been a steady insistence on the doing of useless work. We might perhaps expect that early stone implements at least would have been strictly utilitarian, but it was not so. Even some palaeolithic tools are considered to have been made with better workmanship than was needed to make them get results.*

* V. Gordon Childe:
*What Happened in History*

Similarly at the present day it is all but impossible to find a manufacturer who assumes that his customers will rather do without the useless work and save their money. Most of the customers may not set any store by the qualities of appearance given by useless work and may not pretend either to value or understand them, yet they will insist on having them and will expect to pay for them, however debased they may be. The maker will be able to sell nothing if he reduces his prices by omitting as much of the useless work as it is humanly possible to omit.

The idea of purely utilitarian design is apparently a fairly recent and sophisticated one. We all, I suppose, have a fairly clear idea of what it is like. The inside of a warehouse, a latticed steel pylon carrying electric cables, an oil refinery, the scaffolding on a building, the manhole of a drain, a steam boiler, a railway goods truck, the chassis

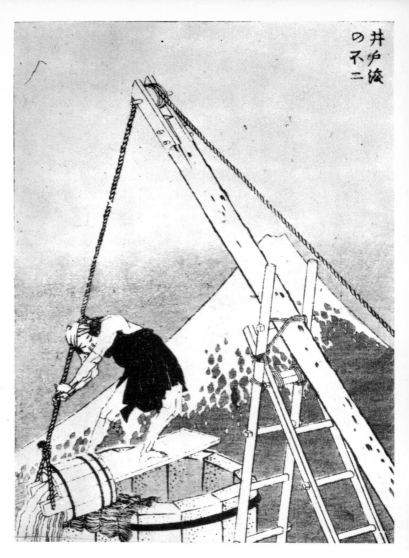

井戸浚の不二

Purely utilitarian design.

of a motor lorry, are examples of it; whereas a living room and its contents are not. The things we call purely utilitarian are things which seem to have been made as economically as is possible consistent with their being efficient, or achieving their intended result.

Now they would not achieve that result any the less effectively if they were made less cheap by doing useless work on them. A steel lattice pylon carrying electric cables does not carry them any better

than a marble column would, or a wooden lattice, but it does so more cheaply in the short or long run.

It seems then that the work we call purely utilitarian is not more useful than its more ornamental counterpart. It is merely more economical. Not much of 'purely utilitarian' design is as utilitarian as we are apt to think. Plastering a brick wall is utilitarian, for it stops the wind coming through (which it otherwise would do to a surprising degree). But making the plaster smooth is entirely useless. Now the same operation which lays the plaster, if skilfully done, also smooths it; so plastering is part utilitarian and part useless. Any number of operations usually regarded as utilitarian have a similar useless content, which, after all, is the better part of workmanship. It does not really matter if walls are out of plumb, yet some builders still bother to make them plumb without being paid extra.

The only work which is entirely useless is the doing of redundant operations or the adding of redundant components, such as applied ornaments.

It is most desirable that the doubtless varied reasons why useless work has so consistently been done, shall one day be examined. This will involve much research. One of the important things to find out will be, what the people who have made and designed useful things have thought about their useless work. The ideas of former days and of primitive peoples about it can decidedly not be inferred from those

Where there is high precision there is always an element of 'useless work' which may or may not be ornament. It is the hallmark of good workmanship

The original Brown gyro-compass

*Crown copyright, Science Museum, London*

Harrison's No.4 Chronometer

*Crown copyright, Science Museum, London*

of our own day. I see no reason to suppose that all those ideas were silly. It may be that we have much to learn from them. I do not believe, as I think Engels suggested of the nineteenth century, that makers exerted avoidable effort only under duress. If they had not been willing to do it, it would not have been done. Why were they willing? It is the ideas of the makers, who as often as not were also the designers, which we need to understand. And how did the extraordinary idea first emerge that useless work really could be dispensed with entirely and that things could indeed be made 'purely utilitarian'?

The idea of differentiating between the useful and the ornamental, between the structural and the decorative elements in design, is not altogether a new one.* Every workman must always have realised that you could at a pinch knock up something pretty crude and yet serviceable, without thought for its looks and quality, so long as it served your turn. (This is a pretty large assumption; but I think that at a pinch, in real emergency, workmen must always have done so everywhere.) But what no one seems to have supposed until the last century was that you could, and even perhaps ought to, base the whole of life on things knocked up like that or little better. The idea must gradually have become current that what had from time immemorial seemed the obvious, the natural, the unremarked and incontrovertibly right way of making things was perhaps really nothing of the sort. Makers and designers must gradually have come inwardly to believe that half their work had been mere frivolity because it had been avoidable, and because some of it had contributed nothing to the satisfaction of men's material wants. This must have affected them like a conviction of original sin. The idea that utility was the purpose of work overpowered them and seemed unanswerable. From that time on perhaps the artist and workman have been weakened by an inward suspicion that they are supporting a lost cause. They have perhaps half believed that the world could get on very well without the contribution that something in them yet compelled them to make.

Workmanship* is very largely useless work and, in the West at least, has seldom been recognised for the art it is. It is never easy to say where workmanship begins and design ends, for the simple reason that workmanship is design. Nine people in ten seriously suppose that the good or bad appearance of things depends on their design alone. Their idea is that the designer puts down his design on paper and gives it to a maker who, simply by following it correctly, produces the result the designer intended. By means of his drawings and specification the

* c.f. De Zurko:
  *Origins of Functionalist Theory*

* For a full discussion, see David Pye
*The Nature and Art of Workmanship*,
Cambridge U.P. 1968.

designer is supposed to give the maker complete information about what is required.

The supposition is wrong because in practice the information never is complete. Life is too short for us to complete it. Always there must be something left to the maker's discretion. Nowadays we are apt to be conditioned to believe that value rests on quantity rather than quality, and so we take it for granted that large or obvious shapes matter more than small or subtle ones and that the total effect of a thing as a work of art depends on the gross shape of it – the sort of shape you can describe in a full-size drawing. We pay no attention to such mere kickshaws as surface quality and fine detail; yet their aggregate effect is very nearly as important. To achieve anything worthy to be called quality you will have to do a good deal more than follow a drawing and specification, whoever made them and however carefully.

There is a good and close parallel in music. The quality of a performance depends on the performers as much as on the score. The performers are said to be interpreting the score, but in fact they are adding intentions of their own to those of the composer, recognising that no score in practice can fully express the intentions of a composer, that it can never be more than an indication, a sketch; and *no designer can in practice ever produce more than a sketch* even though his drawing is dimensioned in thousandths of an inch and his specification is as long as your arm. For the matter of that, how very few things can ever be precisely expressed. If designs and scores need interpretation, so do contracts and Acts of Parliament, commands and Holy Writ.

The most noticeable mark of good workmanship is a good surface whether rough or highly finished. It is difficult to over-emphasise the importance of surface quality. We see one thing and only one thing: surface, the frontier of something invisible. No seaman has ever seen a ship. All he has seen is a more or less complete coat of paint. No doubt a ship has been propping it up, but the ship and the paint are not the same thing and no amount of argument will make them so. If he sees the ship in moonlight or in a photograph he will be unable to say anything about its colour and may well be unable to make out the exact shape of it, but he will see the surface, still. In discussions about art much is said of form and colour and little or nothing about surface, yet surface may be visible while neither form nor colour are distinguishable. Something is there to be seen independent of form and colour, and the quality of it is only less important to art than is the gross shape of things. The beauty of anything made of wood depends on surface

quality to such an extent that a bad coat of polish will ruin the best of furniture as certainly as pocks and scabs will ruin the loveliest face. In neither case has the shape, or colour even, of the features been perceptibly changed; what is generally called the design has not been altered at all, yet the good design is of no avail against the foul surface.

One simple reason why so little is said of surface quality is that we have nothing to say it with. We lack terms. Our way of talking about surface quality as 'texture' is rather like the ancient Roman way of calling anything bright coloured 'purpureus' on the principle perhaps that any bright colour was much the same as any other, and so a swan could be as 'purple' as an emperor.

Our want of feeling for surface can again be seen in the frequency with which people decorating their houses remark on the difficulty of matching the colour of paint to the colour of cloth or wood, holding the samples in their hand meanwhile – at which distance from the eye the appearance depends on surface quality quite as much as upon colour. The two can never be brought to any sort of similitude until they are placed so far off that their specific surface qualities have been lost to the eye.

Under a microscope, of course, the qualities of a surface will turn out to be qualities of shape, just as the edge of a razor, so it is said, turns out to resemble the coping of a dry stone wall. Although the naked eye is unable to resolve the separate particles, grooves, hillocks, transparent or translucent glazes and whatever else may be revealed by the microscope, yet it is able to discriminate very nicely between the blended effects of these in different kinds of surface.

This sensitivity and the sense of quality in general, belong to the makers particularly, and have come to them not because of making by hand – whatever that may mean! – but because most things can only be made in reach of the hand, and so at a certain distance from the eye. A maker is in the habit of seeing things close to him and looking at them closely. He will be all but incapable of looking at the works of man as though they were so much scenery, as an interior decorator or an exhibition designer might see them.

There is no space here to write what needs writing about workmanship. Some wonderful things do get written though. The two oddest propositions I have met are:

a That workmanship is bad unless it is perfect.

b That workmanship is bad unless it is imperfect.

Sooner or later I hope to find them being defended both at once.

Green aero-engine, 1911

*Crown copyright, Science Museum, London*

Gnome aero-engine, 1908

*Lent to the Science Museum, London
by Sir F. K. McLean*

Architecture is differentiated from engineering and from nearly all other branches of design by the fact that the architect has to act as if no object in the result, except the earth itself, is given. His first preoccupation is neither with how to get the intended result, nor with what kind of result to aim at, but with deciding what the principal objects in the result shall be.

The intended results of building are an improved climate or weather, along with protection for those who enjoy it, and their goods. These results can only be achieved at present by way of an intermediate result, which is, a limited space enclosed. As soon as someone invents a way of improving the weather even over limited spaces without enclosure, the profession of architecture will change a good deal. But for the present, enclosure of space is a necessary intermediate result towards improved weather, except in the South Seas, where shade is enough.

It is not often difficult to design a system of things which will effectively enclose a limited space, and even if for one reason or another it does prove difficult, the architect's problem in that is not essentially different from the engineer's. He may indeed consult an engineer to help him solve it. The architect's special preoccupation is first to decide what kinds of spaces shall be enclosed. The spaces enclosed are the objects in the result. The kind of result the architect intends is always the same but each particular result of that kind will involve different objects, for different shaped pieces of space will have to be enclosed. The planning of buildings consists first in deciding what those shapes shall be and then in relating them to each other. It is as though a civil engineer had not only to design a dam but first of all to design the water. In nearly all other fields of design one at least of the main objects is given at the start, but to the architect it is not given.

But of course what the architect is enclosing is not space but a fluid, namely air, which like water takes the shape of what encloses it. Strictly then, after all, one of the objects in the result is given to him as to all other designers. But he must proceed as if he were enclosing something which had first to be delimited and then surrounded at the

'The weather in the space'
chapel at Ronchamp designed
by Le Corbusier

*Photo: René Burri*
*Copyright: Architectural Design*

limits. Space for him is something to be cut and carved into shapes and then built round.

All manner of different considerations will influence an architect's decisions about the shape of the spaces he is to enclose, but the chief of them will always be the probable activities of the people who will enjoy the weather in the space. The people using the furniture in a room and circulating among it will sweep out paths in space which must be accommodated by the room; and those paths together make up the space required for the room. But the space of the room may have been predetermined for other reasons, in which case it will govern the paths. The paths and the space as a rule have to be modified to suit each other. They may of course each have to be modified to suit other things as well. The audience and its movements in a concert hall have to be provided for, but the hall is a component of an acoustic system as well as of an enclosing system. The arrangement necessary to the acoustic system will influence the shape of the space to be enclosed. Compromise is involved here as much as in any other branch of design.

Considering that we use things only in order to get results and that in every useful action we perform we are constantly preoccupied with its result, it is really very odd that we have no names for results as such. When we propose to explain what some device or other is for we do so not by referring to the result which is its *raison d'etre* but by referring to the mode of action by which, so we say, it gets its result, which according to the dictionary means its function. We say it is 'for cutting' or 'for supporting' or some such expression.

Now things, as I hope to have suggested, do not by themselves have any actions or modes of action. Men have modes of action and impute to things what they know about themselves. We think of things anthropomorphically. We say a knife cuts, a drill bores, a piece of glass scrapes. But cutting and scraping can only be differentiated objectively by comparing certain results, or the systems which give rise to them. If I am teaching someone to carve with a sharp tool I may say 'Use it like this and it chops away the waste; use it like that and it skims off a shaving thin as paper; use it so, and it merely scrapes; use it so, and the tool will break near the edge, because it is ground very thin.' What I am trying to do is to explain what result will arise if the system including the bench, the wood, the gouge, and myself, is arranged in this way, and that way, and the other. It is the difference between the results that I am interested in, yet I attempt to explain all this by imputing actions to the tool, as if it were alive and capable of doing things all by itself.

**Fig. 16a**

**Fig. 16b**

We speak of the mode of action of a thing. Action, considered apart from the thing acting, can only be a matter of force and movement. If there are specifically different modes of action of one thing, such as cutting and scraping, there must be a difference in the forces or the movements involved in each. Take a sharp knife, apply it to a smooth piece of wood as in Fig. 16a. Move it from right to left under a slight downward pressure, and it cuts a thin shaving. Take the same knife and apply it as in Fig. 16b, move it from right to left with the same downward pressure, and it scrapes. The forces in each case may be the same and applied in the same direction, the same amount of force acting vertically and the same amount horizontally. The hand and the knife may move

Fig. 17

through precisely the same path at the same speed in the same direction. In (a) there is cutting and in (b) there is scraping, but there is no difference either in force or motion. The point may be demonstrated still more conclusively if a plane is made so that the cutter can be set either vertically or at 45° to the sole. Then if the same plane is used first with one setting and then with the other the downward force in either case may be provided by the unaided weight of the plane. The hand moving the plane will be in precisely the same position in either case, the force applied may obviously be the same if the 'cut' is adjusted carefully, and so may the path through which the edge of the cutter moves.

Now someone may raise an objection to this argument and say, 'You have only considered the recognisable motions and sensible forces. It is obvious that the forces which act at the edge of the tool when it is cutting differ from those which act when it is scraping.' He is quite right. I reply 'Yes. How do you know? Have you measured them?' He replies 'No. But it is obvious. Look at the position of the cutter in each case, and the different shape of the shavings and the worked surface.' He has in fact *inferred the action from the system and the result*. Modes of action always are so inferred. The only way to differentiate the actions in this example would be by instrumental measurement. Moreover we are quite prepared to say two actions are the same when the motions and forces acting are evidently different. In Fig. 17 we should ordinarily say that the wedge was splitting the log whether the force was applied in the direction A or the direction B. Yet at A it is wedging the crack apart while at B it is levering it apart. At A the wedge splits as it moves in; at B it splits as it comes out, turning. We say its mode of action is splitting simply because there is a split to be seen: a result. If different results arise in similar systems, then different forces are involved. True. But we have rarely any direct knowledge of the forces acting. I understand that no one really knows yet exactly what happens at the edge of a cutter and what forces the atoms of it and of the thing cut exert on each other. The function of a cutter in fact is unknown. We have no means of distinguishing modes of action as such, and we lump together actions which are quite different. In the case of the wedge just quoted, two actions as different as pulling is from pushing are both given the same name because they give the same result – as pulling and pushing may do. We judge by results in fact, though we do not name them.

We differentiate between the modes of our own actions easily enough

for we are inside them, so to speak. We do not think about the forces and movements in them and are scarcely conscious of these, very often. We are however well aware of what each action feels like, and that they feel different. The forces and movements may be identical whether your jaw drops in horror or whether it drops to let in a piece of steak. The first mode of action is gaping or gasping and the second is eating. We know whether we are gaping or eating by the sensations and associations and other internal carryings-on which accompany those actions. The difference between the actions is subjective and perfectly clear. There may be no objective difference. When we see someone else opening his mouth we know whether he is gaping or eating by the context of the action. Similarly, when we see a tool moving we know whether it is cutting or scraping by the context of its action, and that is, the system in which the action is taking place and its result.

How else could the teacher of carving have referred to the results in which he was interested? He might have said '... it will give a scraped result' or something of that sort, but he could find no noun with which to refer to the result directly, and so he had to impute actions to the tool which he inferred from the result. Here perhaps is the clue to some of the confusion of thought about 'function'.

If we want to arrive at any sort of understanding of the nature of design we must stop vapouring about the mode of action by which a

thing serves a purpose and consider the class of system from which an intended result can arise. It is well enough to use the verb 'to function' meaning 'to work', i.e., 'to give rise to the intended result'. But the noun function as mode of action refers to something of which we can seldom have any knowledge.

It may of course be argued that in spite of the dictionary, what function really refers to is the intended result. 'Form follows the intended result' sounds reasonable enough. Now a crane, a lever, and a bottle-jack are all intended to produce the same result and do produce it. So, if form follows function, and if function is the intended result, they all have the same form. If not, why not?

As a matter of fact, 'function of' equals 'result of', or 'what it causes', seems to be approximately the biological and medical usage (though in some instances 'what it causes' is seasoned with a drop of 'how it does it'). Sentences are found such as 'the function of the cerebral cortex is to provide us with . . .' One could hardly substitute 'mode of action' here!

Louis H. Sullivan, who expatiated on form following function in a most entrancing manner ('. . . the form, wave, looks like the function, wave . . .' etc., etc.)* quite evidently meant by function something approximating to the Platonic Idea: the eternally existing pattern of which individual things in any class are but imperfect copies. But apparently he did not consider that the copies of it were necessarily imperfect. He considered that the Idea (which he chose to call by the name function) was continually striving to find perfect expression; the Idea being something willed by God, and active on its own account; active moreover through the agency of human invention (in its widest and least restricted sense) so that the form axe might be a perfect expression of the Idea axe for all that it was not a natural form, but man-made.

Sullivan did *not* say that function was the mode of action by which a thing or a system fulfilled its purpose. On the contrary he implied as clearly as possible that it was something altogether different and something mystical which quite transcended such a conception. It is not clear why he used the word function at all. Perhaps the doctrine of functionalism in its received form, took that form simply because the people who read Sullivan naïvely supposed that words have fixed meanings tacked onto them, and supposed that because he wrote the letters f-u-n-c-t-i-o-n he intended the meaning which appears after those letters in a dictionary.

* Louis H. Sullivan:
*Kindergarten Chats and Other Writings:*
'The Documents of Modern Art'

Because there has not been any coherent theory of the nature of design, and because it is evident that what a thing does has some bearing on what it looks like, 'function' has been loosely used to cover any or all the factors which limit the shape of designed things independently of the designers' preference. It has diverted attention from the fact that those influences are many, disparate, and of various effect, and particularly from the fact that economy, not physics, is always the predominant influence because directly and indirectly it sets the most limits. 'Function' apparently covers economy as well as anything else you please. It is a wonderful hindrance to any understanding of design and will die hard, for it makes a fairly intricate subject look simple.